IMAGES
of America

SOUTH BETHLEHEM

IMAGES
of America

SOUTH BETHLEHEM

Kenneth F. Raniere, Karen M. Samuels,
and the South Bethlehem Historical Society

ARCADIA
PUBLISHING

Published by Arcadia Publishing
Charleston, South Carolina

Printed in the United States of America

Library of Congress Control Number: 2009937652

For all general information contact Arcadia Publishing at:
Telephone 843-853-2070
Fax 843-853-0044
E-mail sales@arcadiapublishing.com
For customer service and orders:
Toll-Free 1-888-313-2665

Visit us on the Internet at www.arcadiapublishing.com

To the memory of Magdalena F. Szabo,
Bethlehem City councilwoman who believed in
the people, the place, and the spirit of "her South Bethlehem."

CONTENTS

ACKNOWLEDGMENTS

Without the support of South Bethlehem Historical Society members and friends, this book would not have been possible. The society was founded in 1985 by Joan Campion and was incorporated that same year with like-minded local history lovers—Adrienne Redd, Magdalena F. Szabo, John W. Trotter Jr., Bernice R. Trotter, and Helene Whitaker. Over the past 25 years the membership has grown. Their generous donations have formed an archive of photographs, postcards, oral histories, and other items related to the history of South Bethlehem. Many of these images have been featured with related articles in the society's newsletter, *Southern Exposure*.

We especially wish to thank the following people who generously opened their family photo albums and shared their collections for the creation of this book: Carolyn Abel, John Abel, Carlos Almeida, Joan Andrews, Stephen Antalics, Roz Bachman, Jane Bannan, Jean Belinski, Michael Belletti, Barbara Suzanne Biro, Pearl Pondelek Bodor, Joseph Brennan, Tina Cantelmi Bradford, Dino Cantelmi Jr., Kim Carrell-Smith, W. Christian Carson, Ilhan Citak, Joe Colucci, Donald Davis, Jim De Souza, Stephen Donchez, Maureen Dresen, Mario Fernandez, Beall Fowler, Marlene "Linny" Fowler, Suzanne Gaugler, Steve Glickman, Ann Marie Gonsalves, James R. Goodin Sr., Dana Grubb, Carol Hafner, Sally M. Handlon, Ron Hari, Jeffrey M. Hauck, Jim Higgins, Jodi Hijazi, John Horvath, Roger Hudak, Tom and Flex Illick, Kenneth Irvine Jr., John Kish IV, Kathryn Broczkowski Klein, John and Jeanne Kosalko, Michael Kramer, Thomas Kwiatek, Ellen Larmer, Colleen C. Lavdar, William Long, Rick Lund, Jeannette MacDonald, Patricia N. McAndrew, Mark McKenna, Lance E. Metz, Thomas and Yolanda Mohr, Jackie Olitsky, John Ortwein, Tony Ortwein, Jeffrey Parks, Rita M. Plotnicki, Frank Podleizek, Louis Polack family, Mary Pongracz, Gregory Ragni, Joe and Barbara Raykos, Sandra Rivera, Stephen and Fran Roseman, Rose Roth, Joseph Santoro, Charles Schneider, Chris Shelbo, Jackie Slifka Schneider, Amey Senape, George Shortess, Donald Sillivan, John Simitz, John K. Smith, Mario and Sandy Solis, Armindo Sousa, Barbara Stoffa, Lenny Szy, Javier Toro, Dave Urban, Christine E. Ussler, Louise Szabo Valeriano, Ettore Vallone, Robert Walch, Meg Sharp Walton, Bruce Ward, Barbara and Merritt Weaver, Lee A. Weidner, Frank Whelan, Alan Wilkins, Sallie Derrico Woodring, and Nevin Yeakel.

Many thanks to Joan Campion, Clifford J. Raniere, John Samuels, Theodore Samuels, Thomas Samuels, Michael E. Schlecht, and Deborah Hartwell, who have contributed their support of this publication.

Unless otherwise noted, images are from the archives of the South Bethlehem Historical Society.

INTRODUCTION

What did the mid-19th-century entrepreneurs who laid the groundwork for the borough of South Bethlehem intend its future to be? What fate did they imagine for the industrial settlement just across from old Moravian Bethlehem?

Perhaps they did not think much at all about the distant future. Heavy industry was on the way, and housing, stores, and other necessities of everyday life had to be supplied for the workers and managers who would work with the new machinery. The workers came from the countryside, where Pennsylvania Dutch farmers and Irish immigrants struggling to make it economically would provide a pool of willing laborers.

But within a few decades more would happen than even the most farsighted South Bethlehem founders were likely to have imagined. With the exception of zinc manufacture, the industrial underpinning of the new municipality survived. After a time, the Bethlehem Iron Works was acquired by Charles M. Schwab and morphed into the Bethlehem Steel Corporation, which helped mightily to win World Wars I and II for the United States and its allies.

As it grew, Bethlehem Steel's need for workers expanded well beyond the numbers available in the Lehigh Valley. Like many other American corporations, it had to send recruiting agents abroad, to Europe and Mexico in particular. South Bethlehem's streets became crowded with members of perhaps 50 ethnic groups and resounded with multiple languages. Churches grew up—Protestant, Catholic, Eastern Rite. There were at least two synagogues and even, for a time, a Hebrew day school.

South Bethlehem was the world in a small space.

It only had an independent existence—mostly as a borough but briefly as a third-class city—for a few decades. Then it became part of the City of Bethlehem. So different was it from the rest of the city that the assimilation continues to be puzzling.

As a latecomer, I can attest to the fact that, 50 years after it lost its political independence, the old neighborhood retained a great deal of its old life and tradition. By now, 40 years later, much more has been lost.

Ken Raniere and Karen Samuels, the authors of this book, are two of the finest local historians I know. Knowing the quality of their work and their dedication, I recommend the book without reservation. I believe it will be an important contribution toward preserving the heritage of South Bethlehem.

—Joan Campion
Founder, South Bethlehem Historical Society

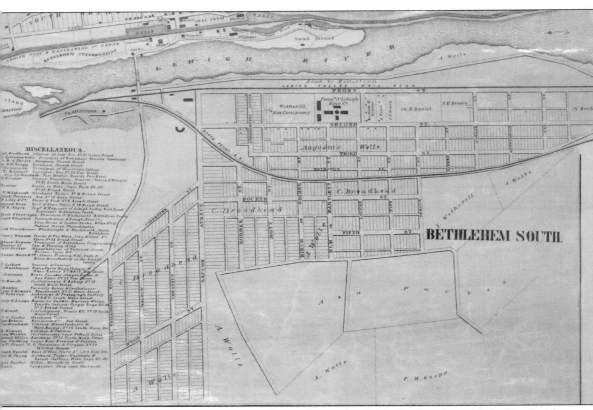

This 1860 map of Northampton County, Pennsylvania, by G. M. Hopkins Jr., published by Smith, Gallup, and Company in Philadelphia, shows the village of Bethlehem South.

One

AN AGE OF INDUSTRY

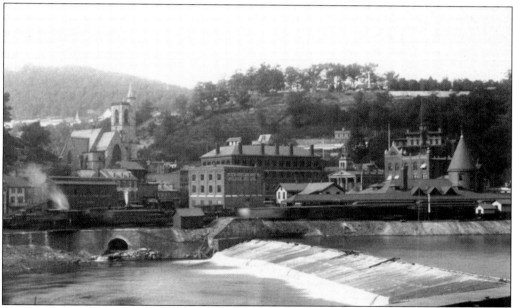

With the discovery of anthracite coal near Mauch Chunk, now Jim Thorpe, the Lehigh Coal and Navigation Company formed and constructed the Lehigh Canal in 1829 to transport the coal to Trenton, New Jersey, then to New York City. In 1855, the Lehigh Valley Railroad laid tracks to follow the same route and purpose. In 1860, Bethlehem Rolling Mills and Iron Company selected South Bethlehem as the ideal location for their furnace. The company took full advantage of the close proximity of the railroad, the ore deposits of the Lehigh Valley, and anthracite coal mined near Mauch Chunk.

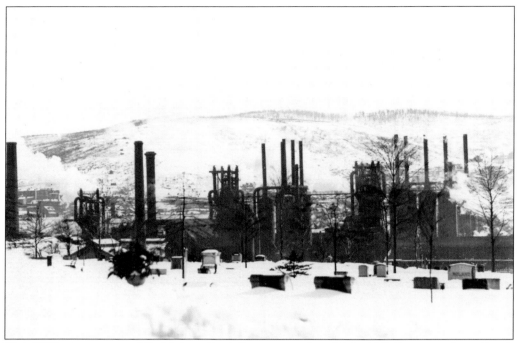

This 1925 winter scene of Bethlehem Steel Corporation from Nisky Hill Cemetery shows South Mountain. Along the Lehigh River, the Lehigh Valley Railroad successfully competed with the Lehigh Canal. In Easton, the Lehigh Valley Railroad met up with the Belvidere Delaware and Central of New Jersey Railroads, which offered access to Philadelphia and New York. These connections made South Bethlehem a desirable location for a variety of manufacturing companies.

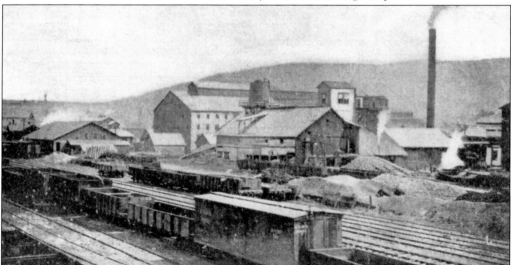

In 1853, the furnaces of the Pennsylvania and Lehigh Zinc Company were built less than 100 yards from the current location of the entrance to the former New Street Bridge, now the Fahy Bridge. It was the first large enterprise established in South Bethlehem. Samuel Wetherill served as the first superintendent. In 1911, Bethlehem Steel annexed the Lehigh Zinc Company property for the production of steel.

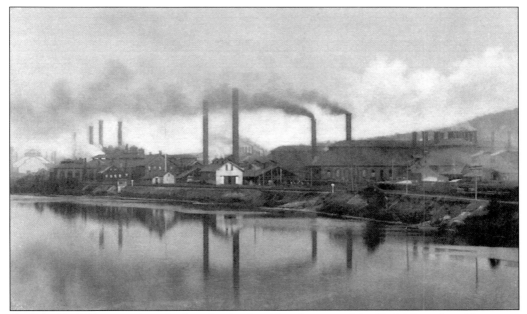

On July 16, 1861, ground was broken for the first blast furnace of the Bethlehem Iron Company. The entrepreneur who led this risky endeavor was Augustus Wolle, a Bethlehem Moravian. The location was selected because of the nearby junction of the North Penn and Lehigh Valley Railroads. In its early years, the company produced rails for the railroads and armor plating for the U.S. Navy. By 1890, Bethlehem Iron was producing gun forging for the U.S. Navy.

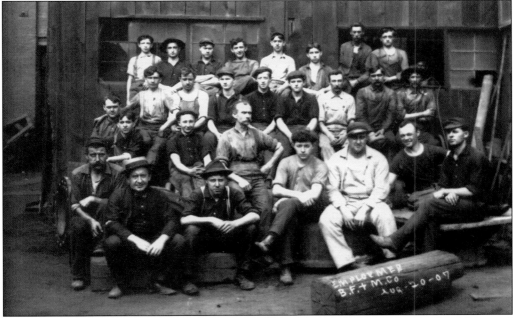

The Bethlehem Foundry and Machine Company was founded in 1857 by M. E. Abbott and Cortright on property originally owned by Asa Packer. They engaged in general foundry work and in the manufacture of cement machinery, repair parts, and chemical castings of all kinds.

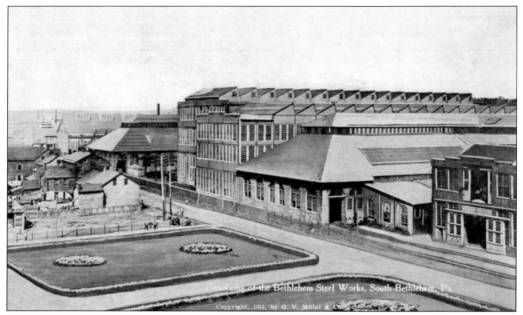

Charles M. Schwab acquired the Bethlehem Steel Company in 1906 and renamed it the Bethlehem Steel Corporation. The plant was portrayed as clean and orderly in this c. 1911 view looking west. Small buildings stand in front of the iron foundry and machine shops, while well-tended greens appear in front of the plate shops.

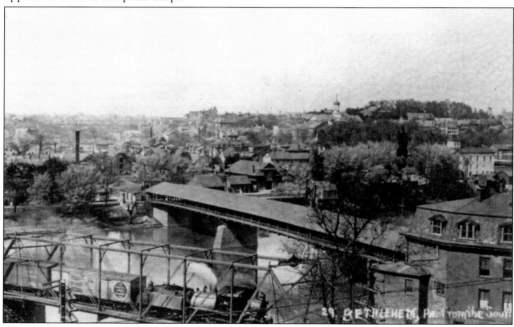

In this view from the anthracite building, looking northeast, an iron-truss railroad bridge crosses the Lehigh River in the foreground and converges with the 1841 covered bridge built by Rufus Graves. In 1892, a trolley line was proposed for the covered bridge but not advised since it was built for lighter traffic and already showed signs of deterioration.

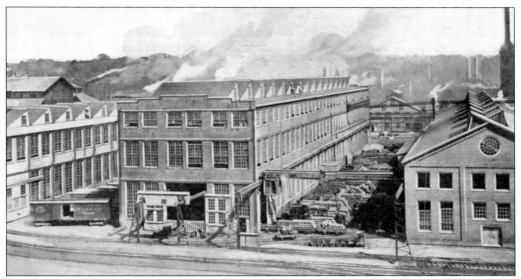

From left to right, Bethlehem Steel buildings in this northwest view of the plant are the Plate Shop, the Stock House behind Machine Shop No. 4, and the Press House for the Projectile Treatment Department. Charles Schwab invested $2 million to improve the steel plant in 1906; Eugene Grace and Archibald Johnston expanded it to prosperity.

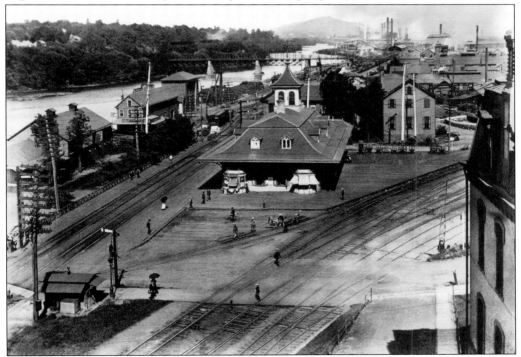

In 1867, at a cost of $25,000, the Lehigh Valley and the North Penn Railroads replaced a brick depot with this iconic Victorian station. The southwestern platform covered the site of the old Crown Inn. The station was demolished in 1924 and replaced by a brick structure in the classical Greek design.

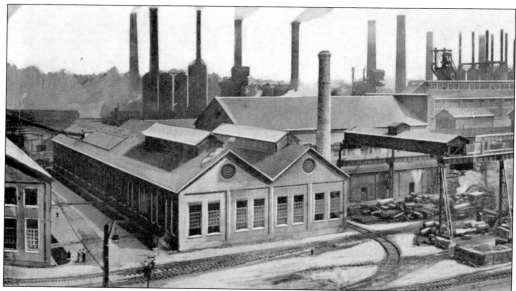

Looking northeast, Bethlehem Steel's furnace chimneys (center, rear) punctuated the sky along with the Power House, the Hoover Mason Trestle (right), and the Annealing and Blacksmith Shop No. 3 (center) buildings. By 1908, Eugene Grace became general manager of Bethlehem Steel; two years later, Schwab turned to armament production and won a $135 million contract from the U.S. government as World War I raged in Europe.

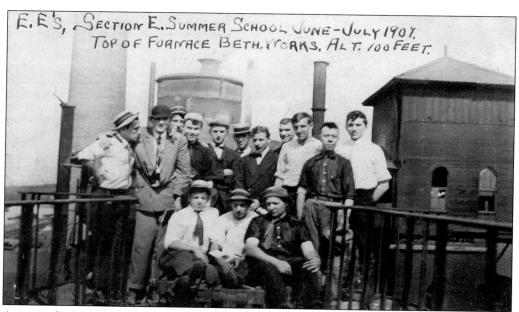

A group of Lehigh University electrical engineering students took advantage of a summer internship offered by the university's neighbor, Bethlehem Steel. At the time of this 1907 photograph, Lehigh University alumnus Eugene G. Grace was general manager of Bethlehem Steel. Grace received his degree in electrical engineering in 1899. In 1920, he started the "Loop Course," a specialized training program for Lehigh graduates, many of whom enjoyed lifelong careers at Bethlehem Steel.

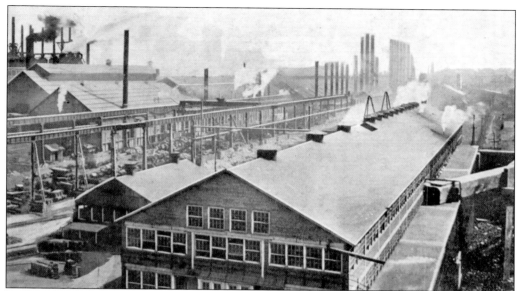

Looking east, structures of the Bethlehem Steel plant featured the Electrical Treatment Building, Drop Forge Building, and Machine Shop No. 2 (center). In 1917, the United States entered World War I; by 1920, Bethlehem Steel was declared the "Arsenal of Democracy" for its war contributions. The greatest steel production took place in 1944, making it the largest shipbuilding plant in the world, which helped to save the nation in war. By 1956, Bethlehem Steel earnings peaked at $161.4 million.

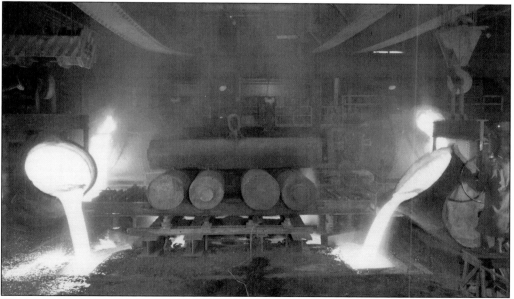

Workers pour 2,700–3,000 degrees Fahrenheit molten steel into molds. They skimmed away impurities called slag to keep it from going into the molds. Slag was later poured from the ladle into a steel-bodied car and transported to a slag dump. Ladles and molds were heated before receiving the steel and were completely dry, as molten steel contacting any moisture would cause a dangerous explosion.

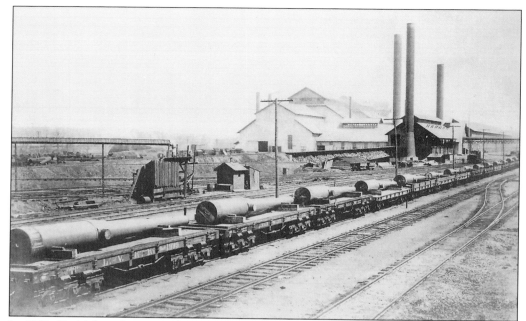

In 1882, Bethlehem Iron won $4.5 million in contracts from the U.S. government to rebuild the U.S. Navy fleet. Under John Fritz's direction, Bethlehem Steel built several open-hearth furnaces and modern forging equipment. In the 1890s, propeller shafts, armor plates, and guns were constructed for the navy. Special railroad cars, seen above, had to be built to carry up to 300,000 pounds of ordnance materials.

Looking east from Wyandotte Street, the large white building is the 1870 roundhouse of the North Penn Railroad. The site encompassed the apple orchard of the former Crown Inn, which was leveled so the roundhouse aligned with the railroad tracks.

16

Two

OUR TOWN

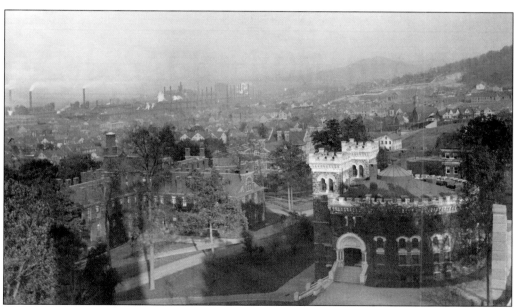

A view of South Bethlehem from South Mountain shows the extensive growth of industry and population in the once rural setting. The air and water were the repository for industrial waste. The workers who chose housing closest to the mills suffered the most from the pollution. The workers in the coke ovens were 10 times more likely to develop lung cancer and leukemia than other steel workers.

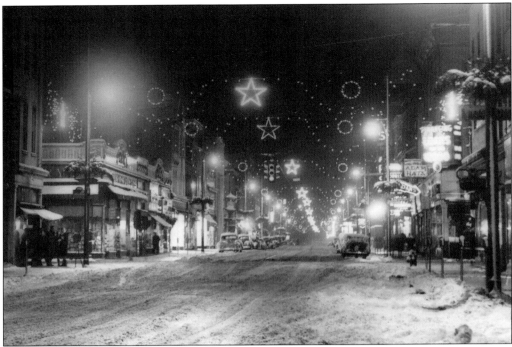

A snowy evening in December 1947 shows the intersection of New and Third Streets. The photograph, taken by Michael Slifka of Slifka Brothers Studio, became a popular postcard.

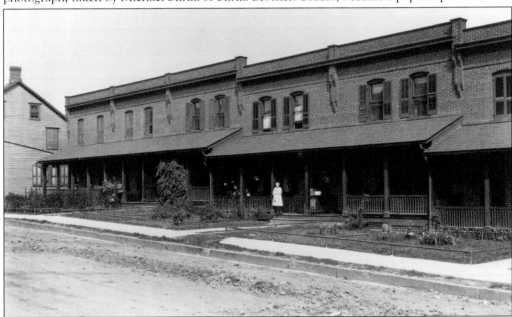

Between 1910 and 1920, Bethlehem's population grew almost 300 percent. Bethlehem Steel needed workers to fill ordnance orders from Britain, France, and the United States. The workers arrived, causing a severe housing shortage. Bethlehem Steel went into the real estate business and built row homes, as in the image above. The company offered mortgages to buy or build homes.

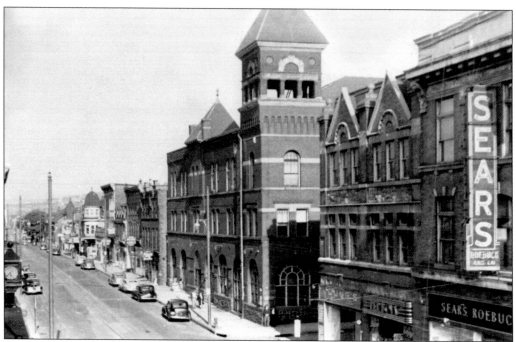

The Borough of South Bethlehem purchased a successful market house from the South Bethlehem Farmers Market Company, established at Third and Adams Streets, in 1875 for $1,000. In 1893, the borough bought up the surrounding lots and replaced the wooden structure with an impressive three-story brick building with a tower, designed by architect A. W. Leh. The first floor continued to serve as a market, the second floor for borough offices, and the third floor as an auditorium.

A MESSAGE FROM HEAVEN

Reelect Our Honorable Mayor

James M. Yeakle for MAYOR

If my past efforts in your behalf meet your approval I will appreciate your vote and support.

James M. Yeakle, mayor of Bethlehem from 1922 to 1930, was running for a third term. He tried a new campaign trick. He hired a pilot to fly above the streets of Bethlehem and drop thousands of the above flyer. The stunt angered the deeply religious citizens of the community who found the message to be sacrilegious. Yeakle lost to Robert Pfeifle, who served as mayor from 1930 to 1950.

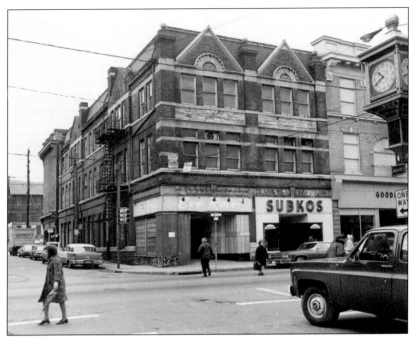

On the corner of the intersection of Third and Adams Streets, Eve Reis Esquire Shop offered women's apparel for retail and dress clothes to rent. Subko's, owned by William Subko, also offered men's clothing for retail and dress clothes for rent. Ben Goodman and Son Furniture store was a staple of South Bethlehem since it opened in 1910.

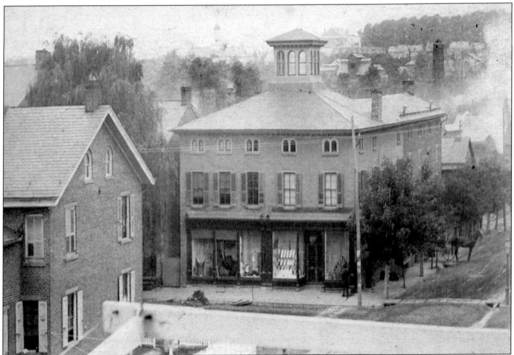

P. Hoffman and Company was a general store at East Third and Adams Streets around the 1890s. It sat on the northwest corner. Notice the interesting square windowed cupola. Hoffman was active in the community. He assisted on the recreation committee for planning the South Bethlehem semicentennial. By 1920, the Bethlehem National Bank occupied the site.

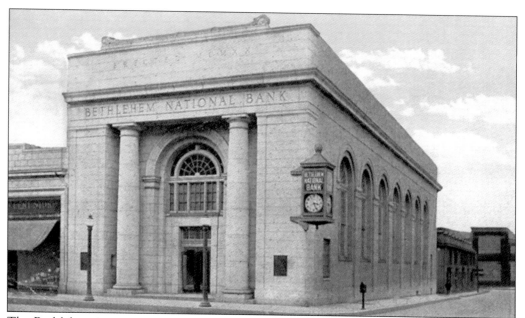

The Bethlehem National Bank was built in 1920. Robert Pfeifle (1880–1958) was contracted to build it. The neoclassic-style building included two substantial Doric columns in its facade. Pfeifle became the bank's president from 1928 to 1933. The Bank of America now occupies the building, and it looks the same today as it did in 1920.

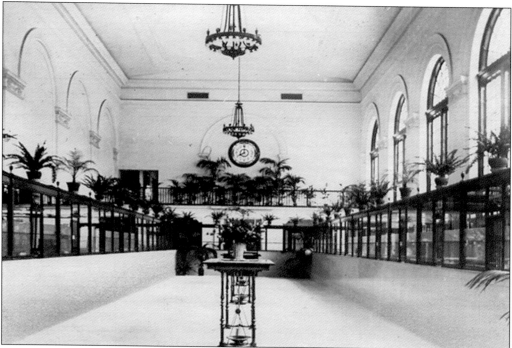

This 1920 photograph shows the interior of the Bethlehem National Bank. The potted palms added an elegant touch. The luxurious interior portrayed the message that the clients' money was safe.

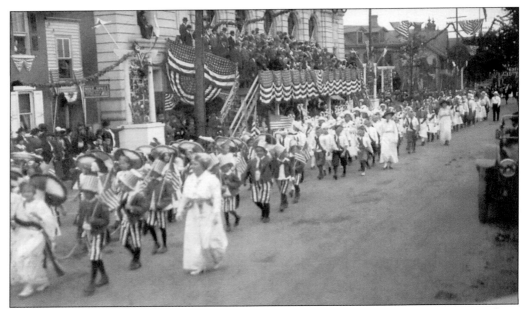

Dressed in patriotic attire, schoolchildren march past E. P. Wilbur Trust Company on Broadway during South Bethlehem's semicentennial festivities in October 1915. In the stand, draped in red, white, and blue, the Bethlehem Steel Band plays to the passing parade.

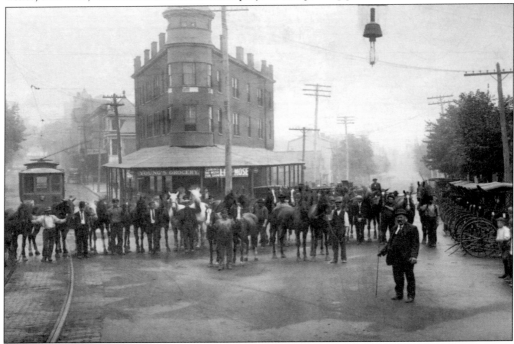

The Ye Olde Ale House at 441 Wyandotte Street opened in 1963 and closed in 1976. It was a popular place to enjoy roast-beef sandwiches. The building served as a grocery store from 1920 through 1950. The Apollo Restaurant opened in 1951, next Emil's Restaurant in 1953, then George's Grill in 1959. The second- and third-floor apartments are in use today.

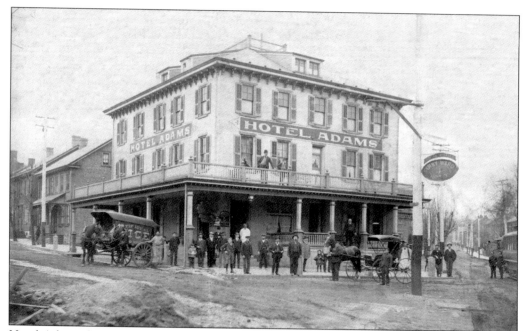

Hotel Adams, located at 509–511 Broadway at Five Points, was originally the First Ward Hotel. Alfred W. Miller was proprietor in 1888. He offered rooms for $1 and had Uhl's beer on tap. William M. Adams purchased the hotel around 1900 and renamed it Hotel Adams. A livery and stable were available. In 1911, the hotel was known as Fulton House and then, in 1923, as Hotel Rudolph. It was razed before the 1930s.

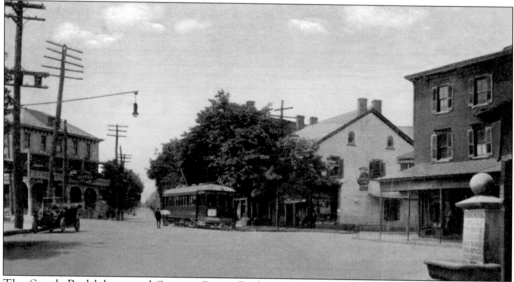

The South Bethlehem and Saucon Street Railway Company began service on May 2, 1909, with a fleet of secondhand cars. The 7-mile route started at Fourth and New Streets; went south on New Street; west on Packer Avenue; south on Brodhead Avenue; west on Summit Avenue; south on Wyandotte Street; up the hill to Seidersville; south through Wydnor, Colesville, and Friedensville; and ended at Center Valley. The running time for one way was one hour.

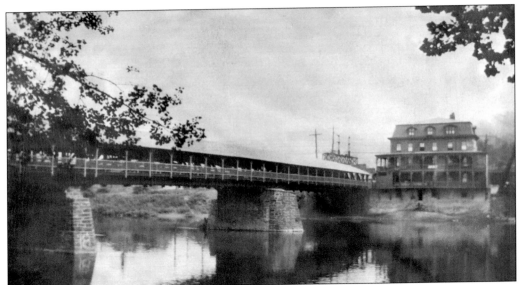

This three-span wooden bridge was built in 1841 by the famous bridge designer Theodore Burr. The bridge was in service until it was replaced by the Hill to Hill Bridge in 1924. The Pacific House, shown here, was also torn down when the new bridge was built. The hotel, under proprietor Thomas F. Marsteller, was in a convenient location near the Union Depot.

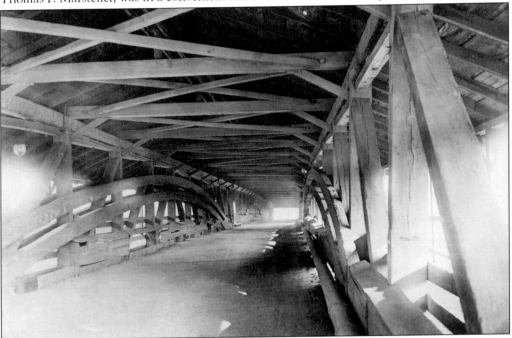

Theodore Burr invented the Burr Truss, an arch-supported truss pictured here. The bridge received most of the traffic over the Lehigh River, as it connected to the road to Philadelphia. The Bethlehem Bridge Company charged tolls for the use of the bridge. A sign over the entrance to the bridge says, "$10 DOLLARS FINE FOR DRIVING ACROSS THIS BRIDGE FASTER THAN A WALK."

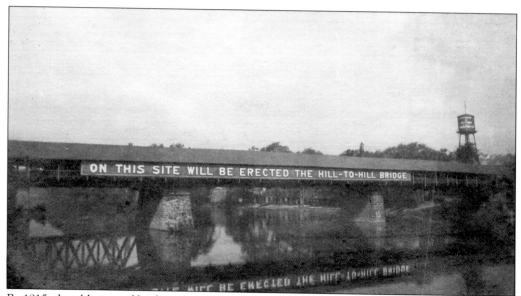

On this site will be erected the Hill-to-Hill Bridge

By 1915, the old covered bridge was closed to heavy trucks and teams of horses. Residents of both Bethlehem and South Bethlehem were exasperated over the delay in building a new bridge. A plan for the new bridge, prepared by engineer Clarence W. Hudson, met the approval of everyone. The bridge spanned between Fountain Hill and a hill located to the west of Church and Main Streets, which resulted in the name "Hill to Hill." When it looked like all obstacles to building the bridge were finally surmounted, World War I broke out in 1917, delaying the construction of the bridge until 1921.

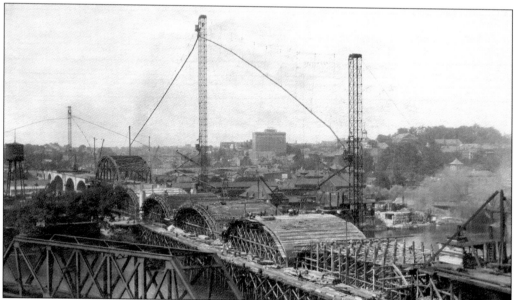

During the war years, the City of Bethlehem purchased 17 properties for the bridge project. At the height of construction, over 400 men were employed. The original bridge had 8 approaches, 11 abutments, 48 piers, and 58 spans. The Hill to Hill Bridge, at 6,055 feet, was one of the largest in the world. It was considered an engineering marvel.

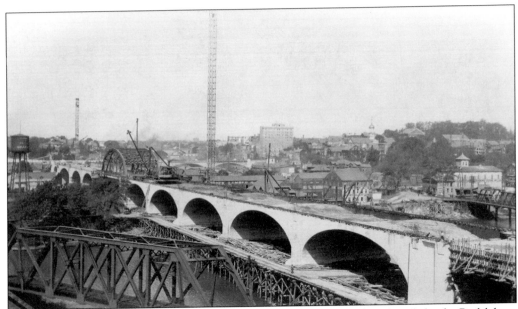

The Hill to Hill Bridge was built with 3.4 million pounds of structural steel made by the Bethlehem Steel Company, 3.3 million pounds of reinforcement steel, and 107,000 cubic yards of concrete purchased from the Pennsylvania Cement Company.

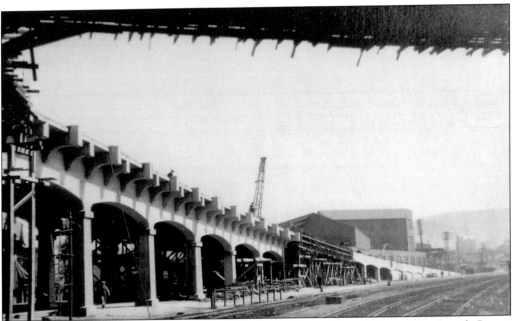

Later structural changes included a new span in 1965 to carry Route 412 over East Fourth Street, and the South Main Street ramp, pictured here, was removed. In 1967, the plaza in the center of the Hill to Hill Bridge was removed, and Route 378 connected the bridge to Route 22. In 1973, the west side ramp was closed, and the Main Street ramp was made one-way. The Second Street and the River Street ramps were demolished by 1989.

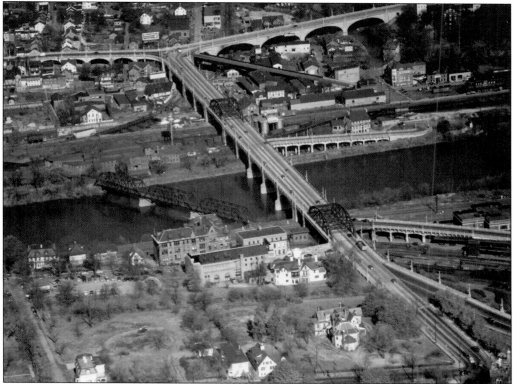

This aerial view shows the Hill to Hill Bridge before the addition of the Route 378 spur. The bridge replaced the old covered bridge, which joined Wyandotte Street to Main Street. Work began on the Hill to Hill Bridge on August 1, 1921, by Rogers and Haggerty, Inc., of New York. It was completed on November 1, 1924, with Frank J. Flecksteiner as the first driver to cross it.

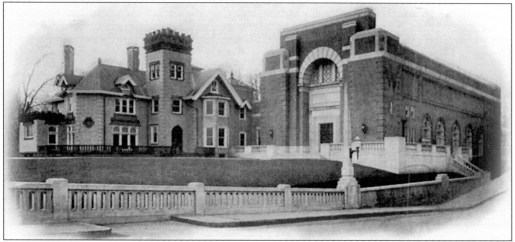

On March 14, 1925, ground was broken for a new Masonic Temple for Bethlehem Lodge 283. The temple is adjoined to the E. P. Wilbur Mansion. The masonry is the oldest fraternity in the world, going back to the Middle Ages. The Bethlehem lodge was formed in 1853. E. P. Wilbur and sons Warren and Rollin were members of the lodge in 1884.

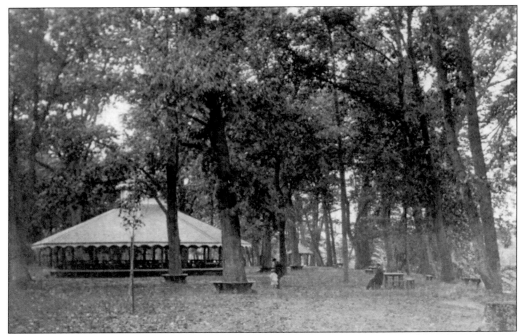

Calypso Island was located just west of the Hill to Hill Bridge and owned by the Moravian congregation. Bethlehem residents arrived at the island by rowboat, canoe, or ferry. Nonresidents were restricted in its use. The island contained about 20 acres of woodland. The carousel in this image provided Bethlehem families with hours of enjoyment.

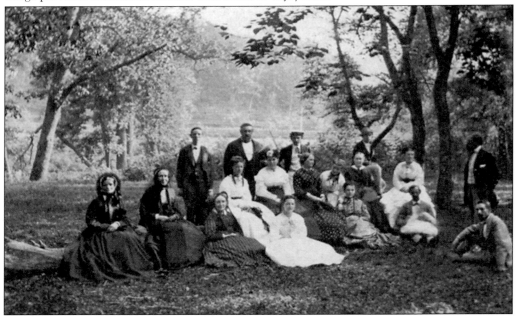

Early summer was heralded by preparations made to enjoy dining al fresco or under the trees in picturesque surroundings. The Moravian family pictured here is enjoying the beauty of the island. A crystal-clear spring located on the island never failed to quench thirsts.

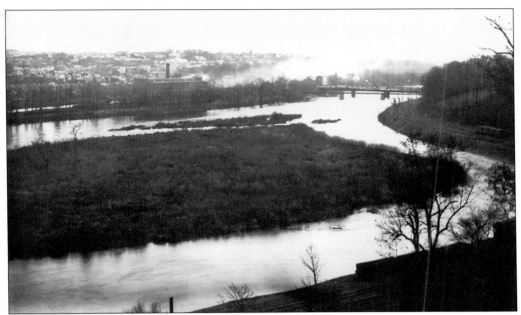

With the arrival of trolleys and amusement parks, Calypso Island fell out of favor as a recreational spot. The Lehigh Valley Railroad purchased the island in 1902. They then denuded the island of all the trees and bushes, as shown in this image. Half of the island was dug up to fill the southern channel so the railroad could straighten its tracks and increase its time.

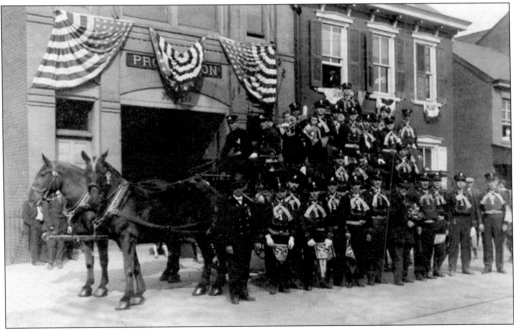

Proud firefighters belonging to the Protection Firehouse on East Fourth Street stand in front of their building with their trusty team of well-groomed dark horses with shiny, polished hooves. The Protection Hose Company was organized on August 5, 1875.

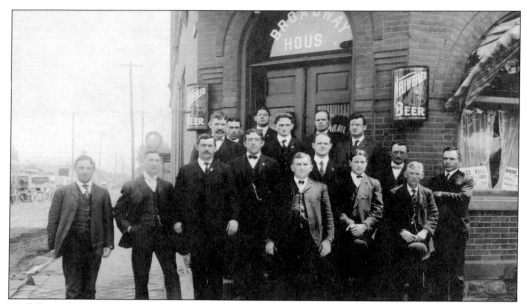

Well-dressed patrons stand in front of Broadway House at the corner of Brodhead Avenue and Graham Court in 1906. In 1916, Joseph F. Kinney purchased the business, converting it into "one of the most modern hotels in Bethlehem." Today Broadway House still exists under a layer of brickcoting and is the home of St. Bernard's Beneficial Society, of which Kinney was a member.

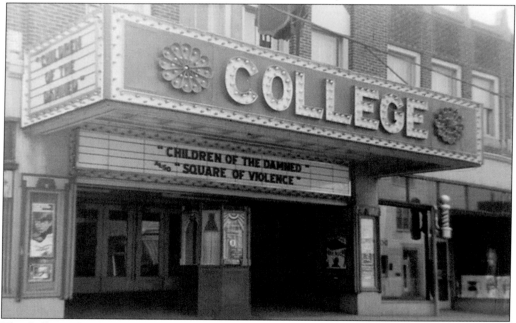

The College Theater at 102 West Fourth Street offered 1,381 seats and was built in the early 1930s. Architect William Harold Lee designed it, and the Cities Theaters Corporation owned the theater from 1935 to 1940. Leggett-Florin Booking Service became the owner in 1950. From 1961 to 1969, the Boyd Theater Circuit owned it. Adult movies were shown there in the 1970s. The block was torn down in the 1990s. The Goosey Gander restaurant is now located on the site.

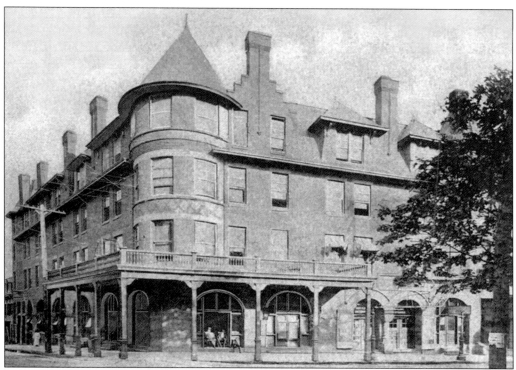

Located at the southeast corner of Fourth and Wyandotte Streets, this structure was originally known as the Fountain Hill Opera House and was South Bethlehem's principal entertainment site for many years. The structure was rebuilt as the Wyandotte Hotel and Opera House in 1888 by E. P. Wilbur. It was closed for renovations at the end of the 1920s.

The Globe Theater at 405 Wyandotte Street was a 1,600-seat theater built in 1888. It was built as an opera house by E. P. Wilbur, a local businessman and philanthropist, as an elegant theater with a large balcony and private boxes. A Robert Morton theater organ was installed in the Globe Theater in 1925. The theater was destroyed by fire in August 1983. The building was razed in April 1984.

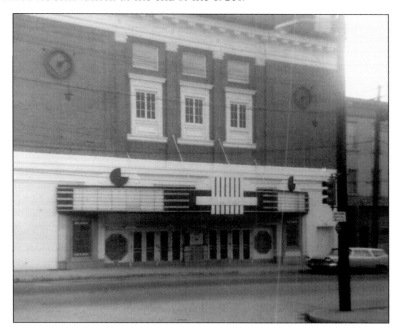

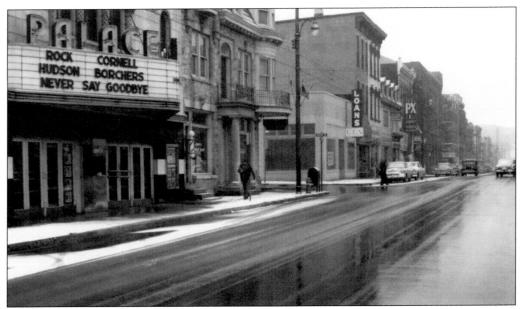

The Palace Theater, located at 206 East Third Street, sat 1,000 people. It was demolished in 1994. The Rite-Aid strip mall was built on the site.

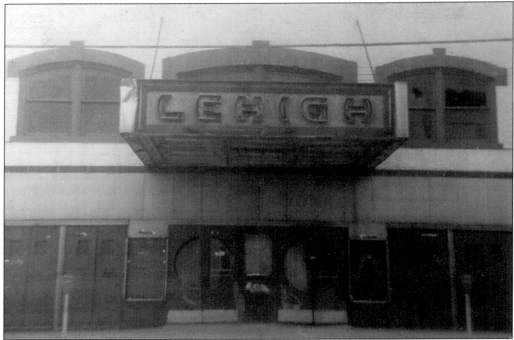

Built in the early 1900s as the Lehigh Emporium Theatre at 20 East Fourth Street, it was advertised as "Refined photoplays for refined people. The largest theatre in town for high class motion pictures." The name changed to the State Theater in the 1930s. In the 1950s, it became the Lehigh Theater and was fondly called "the bug house." It was demolished to build the Fred B. Rooney senior citizen high-rise in 1976.

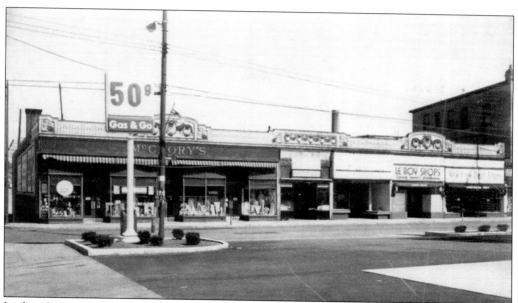

In the 1960s, gas was only 50¢ at the Gas and Go at the corner of New and Third Streets. Across the street, at the McCrory's Five and Dime Store, was the only place to purchase Oriole label 33 rpm records, which covered swing, jazz, big bands, and the blues.

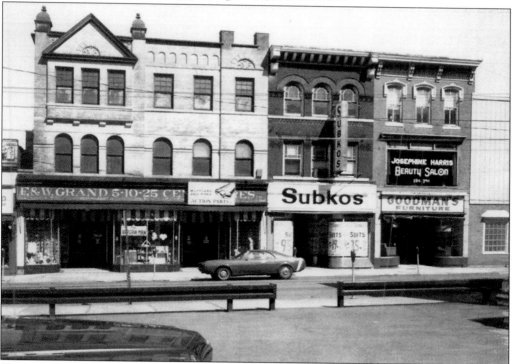

Shopping on Third Street in the 1960s included the F. and W. Grand Five and Dime, located at 13 East Third Street. It was a popular place to buy household items, toys, and candy. F. and W. was bought out by H. L. Green Five and Dime in the 1950s.

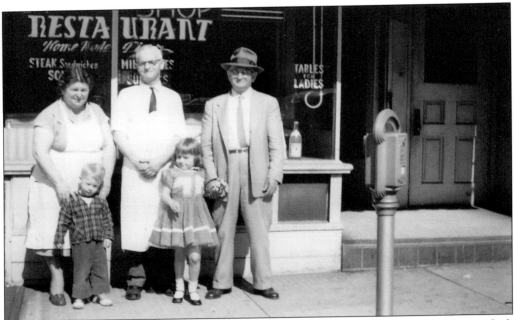

Pictured from left to right, Rose and George Corvis, an unidentified gentleman, and young Jack and Jody Pheiff stand at the Cozy Spot Restaurant, where steak sandwiches, home cooking, and tables just for ladies were featured in this East Fourth Street eatery in 1957.

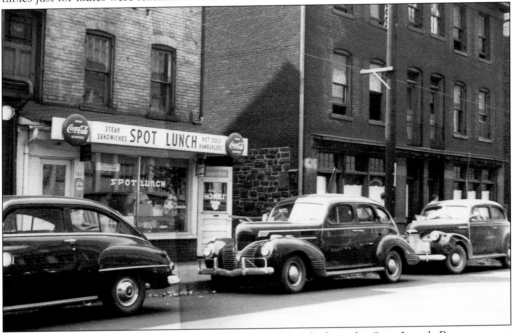

Quick on service, where else could one get a spot of lunch than the Spot Lunch Restaurant at 740 East Third Street? The establishment offered the usual fast foods from the 1940s through the 1950s for discerning patrons on the go: hot dogs, hamburgers, steak sandwiches, Coca Cola, and Hershey's ice cream. Take out service was also provided.

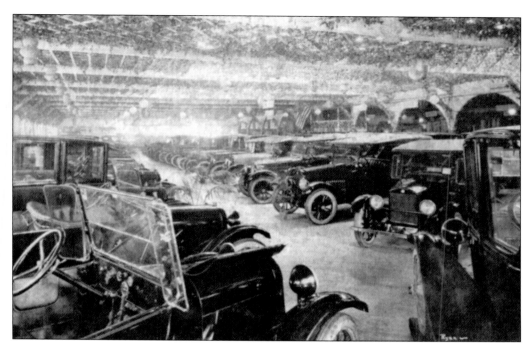

The first automobile show in the Lehigh Valley occurred in 1914 at the Colosseum Roller Skating Rink on Montclair Avenue and Broadway. The show was so popular it became a yearly affair. The rink was expanded in 1917 from 20,000 feet to accommodate 100 vehicles on the floor. Some of the makes of cars included Chandler, Franklin, Stanley Steamer, and Packard.

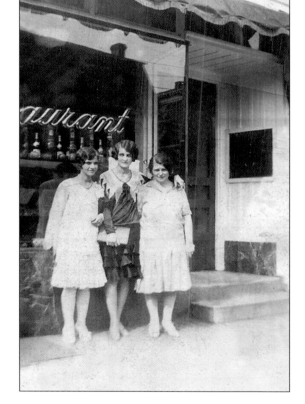

In 1928, Atlas Restaurant's motto, "Pure Food and Prompt Service," seemed the perfect combination for, from left to right, Rose Gadaska, Ethel Samu, and Rose Corvis, who were dressed to dine at the restaurant's 7 West Fourth Street location. Later Atlas became the Royal Restaurant and was known for its great "fast foods." It closed in the early 1970s.

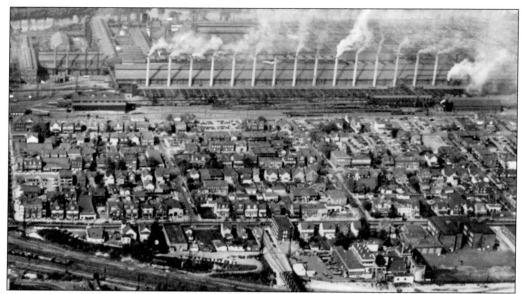

From a gritty and economically challenged working-class neighborhood to its infuriating and ironic demise, Northampton Heights became an urban legend to many who called it home. The elimination of Northampton Heights in the 1960s was a direct response to a national, debilitating urban condition that affected the entire city of Bethlehem.

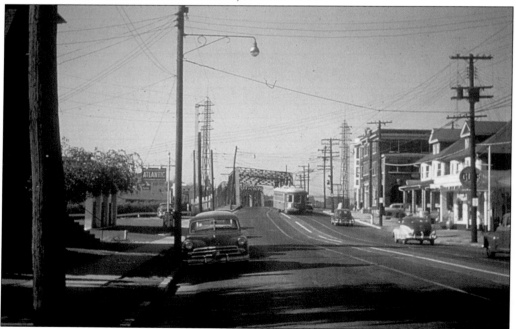

A trolley crosses Fourth Street at Anthracite Street in 1950. Warren A. Wilbur (1859–1932), vice president of E. P. Wilbur Trust Company, and Albert Brodhead (1867–1938), real estate broker, were partners in an endeavor to sell lots in a housing crunch during the 1890s. They purchased the 92-acre Pearson Farm east of South Bethlehem's border. They laid out lots, 40 by 140 feet, for $220 each. The area became known as the Borough of Northampton Heights in 1892.

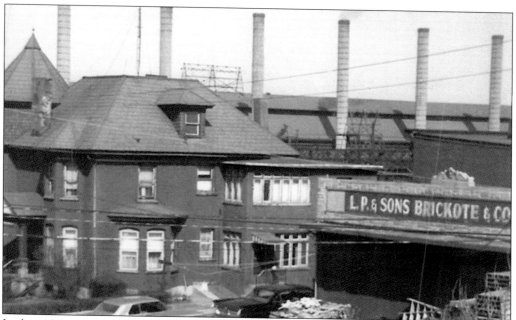

In the 1930s, Louis Polack patented a cement-coating process called Brickote that he used to cover facades of deteriorated buildings. Polack established his business at 1604 East Second Street next to the family home in Northampton Heights.

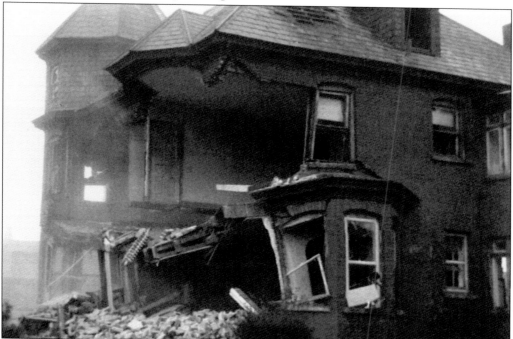

In 1965, the City of Bethlehem declared the entire neighborhood of Northampton Heights "blighted" under the Urban Renewal Area Project. This photograph shows the city bulldozers demolishing the Polack family home in October 1968.

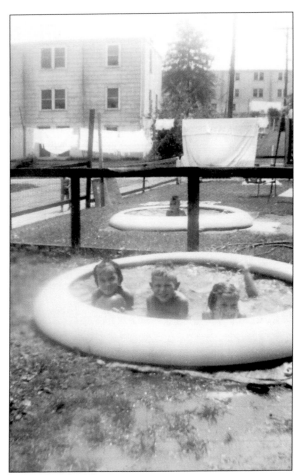

In 1939, South Terrace was built by the Bethlehem Housing Authority. The barracks-style housing was designed to be temporary war housing for Bethlehem Steel workers. After the war, the housing authority decided to keep the structures as public housing. From left to right, siblings Justine, Eddie, and Jackie Ferry enjoy their inflatable wading pool during the summer of 1951.

The former first lady, Rosalynn Carter, visited the complex in 1980 and assisted Bethlehem in finding the funds to modernize the housing. Between 1980 and 1986, the homes were demolished. The authority built 200 new duplex units known as Lynfield. In December 1951, Justine Ferry (left) and her sister, Jackie, enjoy a romp in the snow.

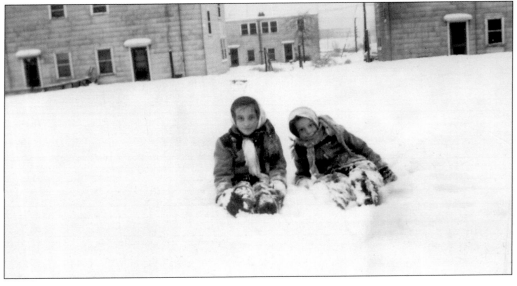

The first Ortwein Hotel built by George Ortwein in 1912 on 1101 East Fourth Street burned to the ground. A new three-story hotel was built on the corner of East Fourth and Hill Streets. George also built three housing units at 1035 East Fourth Street and also ran the Ortwein Dairy he bought in the 1930s at East Fourth and Williams Streets.

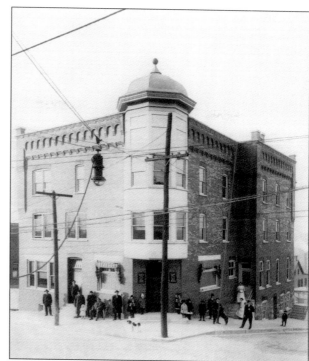

George Ortwein met Barbara Kugler in South Bethlehem in 1902, and they were married in Holy Ghost Roman Catholic Church. At the hotel, they tended the bar on the first floor, which featured a mirrored back bar framed in varnished oak. George and Barbara Ortwein were the parents of 10 children.

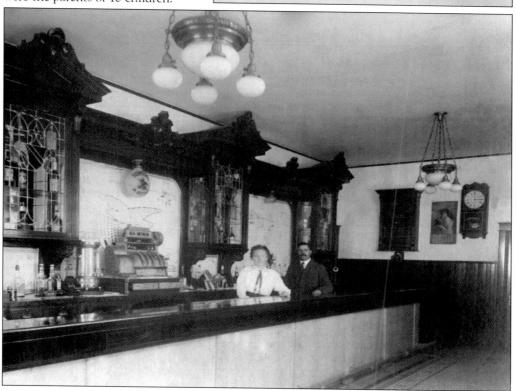

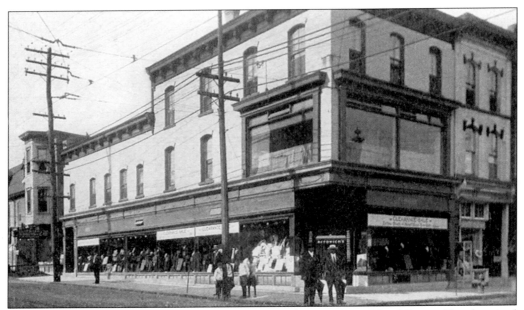

Around 1915, Abraham Refowich set up an eloquent shop at 2 West Third Street. He advertised himself as "the man's outfitter" and offered a complete line of shirts, hats, socks, and suits. Refowich arrived in the United States in 1876 from Kalvarija, Marijampoles, Lithuania. With the assistance of his two uncles, Levi and Israel, he established himself in the business of men's attire in various businesses in South Bethlehem and Bethlehem. His Third Street shop closed in 1969, and the building was lost to a fire on August 31, 2009.

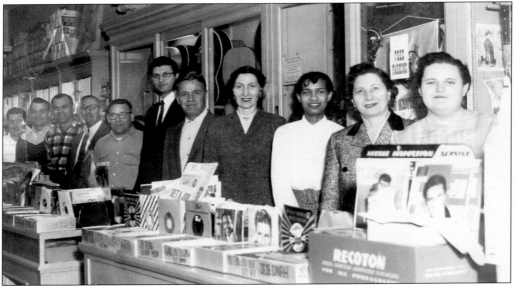

The Phillips Music Store was located at 24 East Third Street. The store opened in the 1920s but endured a rocky start, as their building was lost to a fire. A new larger building was erected in 1925 at the Third Street location. Sol and Rose Phillips were the proprietors and offered 78, 45, and 33 1/3 rpm recordings; sheet music; record players; and musical instruments. The photograph was taken in the 1950s.

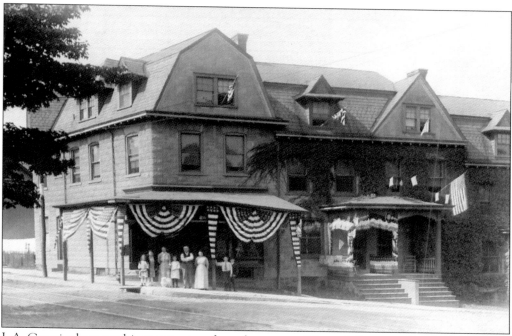

J. A. Cunningham ran his grocery store from the corner of Summit Street and Montclair Avenue around 1915. His customers could buy three pounds of chicken for 19¢, a dozen eggs for 36¢, and a pound of coffee for 20¢. The structure today is an apartment building.

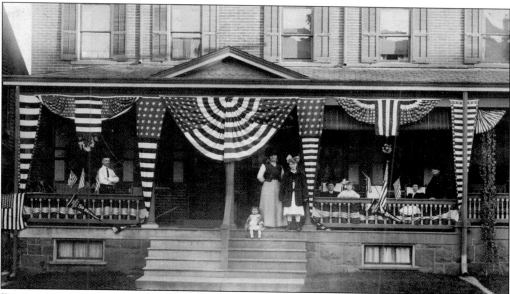

During the semicentennial celebration of South Bethlehem Borough during the week of October 3–9, 1915, his home on Broadway reflected Willis Weaver's patriotic support of the event. The weeklong celebration featured parades and fireworks, including the placing of the new high school cornerstone, soon to be built at Brodhead and Packer Avenues.

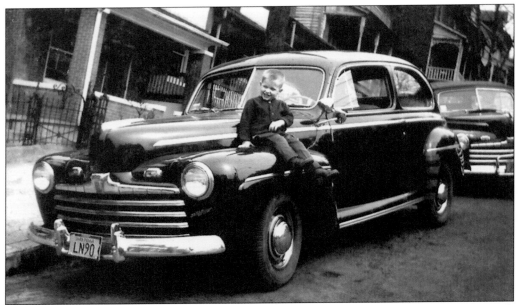

Seated on his dad's 1947 Ford, three-year-old Kenneth Irvine Jr. enjoyed life on the East Sixth Street hill. The steep hills in areas of South Bethlehem were challenging to drive and park upon. Residents used coal ashes from their home furnaces to create traction for their tires on snowy days. It was difficult for children to learn how to ride bikes, roller skate, or play ball on the extreme inclines.

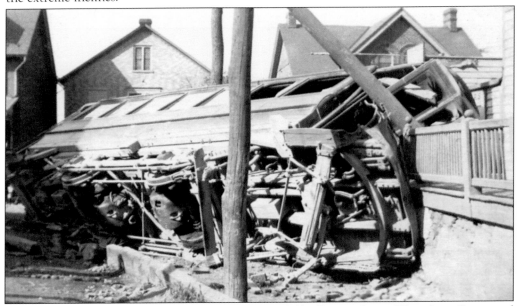

On October 13, 1918, Trolley No. 10 careened downhill off its tracks on Wyandotte Street and crashed into the side porch of Alfred E. Ueberroth's house on Summit Street. Injured passengers were helped to safety by residents and policemen. Two passengers died in the mishap. In 1929, the South Bethlehem Railway Company discontinued trolley service, refusing to regrade its tracks on Brodhead Avenue.

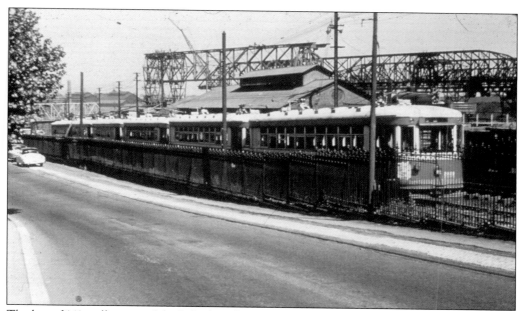

The last of 141 trolley cars of the Lehigh Valley Transit Company travels adjacent to Daly Avenue to Bethlehem Steel's open yards, where they were burned, cut up, and used as scrap in June 1953. The Lehigh Valley Transit Company ended their service in September 1951 due to competition from automobiles, busses, and trucks.

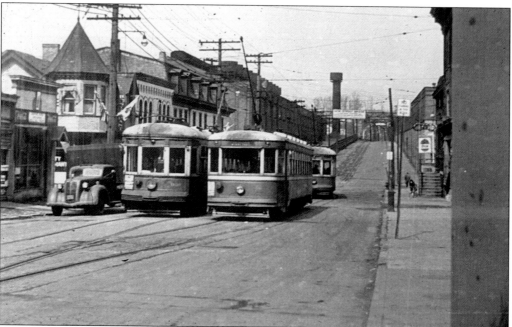

This view of New Street at the corner of Third Street shows trolleys and traffic south of the New Street Bridge seen in the distance. In 1920, the transit company operated over 196 miles of rails throughout the Lehigh Valley. Seven years later, the motorman was the sole employee operating the car without a conductor. By 1941, fares rose from 5 to 10¢.

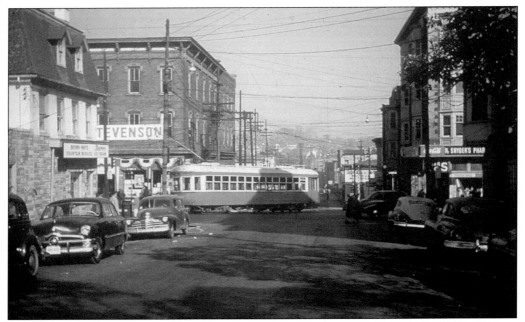

Looking north on Fourth and New Streets, a trolley car makes a turn during the 1950s. Trolleys had replaced horse-drawn transportation in the 1890s. The Lehigh Valley Transit Company was one of the last interurban systems in the eastern United States before converting to busses.

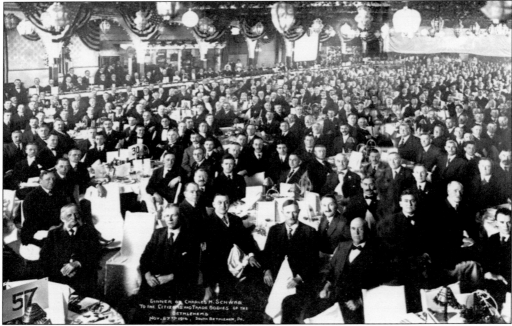

On November 27, 1916, citizens and trade members of the Bethlehems attended a dinner at the Colosseum given by Charles M. Schwab to kick off the campaign to consolidate the Bethlehems. Each attendee found at their place a neat leather case containing two fine cigars wrapped in foil bearing the date, "November 27, 1916."

South Bethlehem's first brewery was Die Alte Brauerie, or Lehigh Mountain Brewery and hotel built in the 1860s by George Rennig, a German immigrant. It was the first brewery in South Bethlehem and was an immediate success. In 1865, Rennig's neighbor, Lehigh University, was established. Lehigh University acquired the brewery in 1897 and converted it into the dormitory. In 1912, the building was named Price Hall in honor of Henry R. Price, president of the board of trustees.

South Bethlehem Brewing Company, located at Webster and East Fourth Streets, followed Lehigh Mountain Brewery in 1902. It produced and bottled beer, porter, and ale under the "Supreme" label for half a century. Coasters pictured the Hill to Hill Bridge, Lehigh University's Alumni Memorial Building, and the Bethlehem Steel Corporation as its "Famous Neighbors."

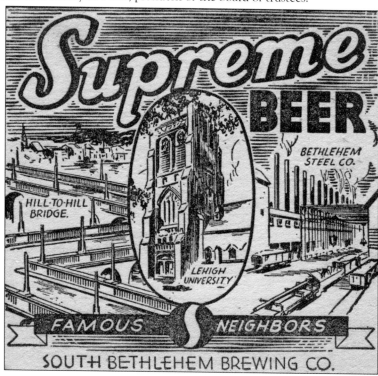

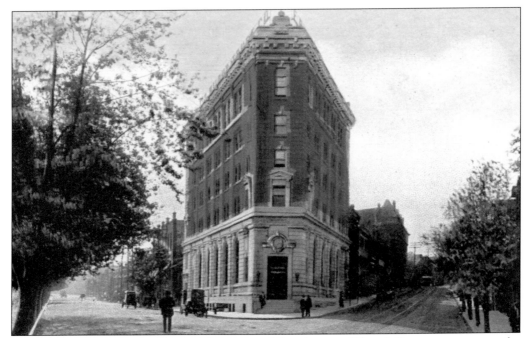

The E. P. Wilbur Trust Building, at the corner of Broadway and Fourth Street, was open to the public on September 30, 1911. The six-story structure, designed by A. W. Leh, was declared by the Bethlehem Globe newspaper as "architecturally, the handsomest, the most modern business building in this section of the state." To this day, it is fondly called "Bethlehem's Flat Iron Building" by the local residents. The original Otis elevator is still in use today.

The E. P. Wilbur Trust Building can be seen from Brodhead Avenue. It was at this location on Brodhead that the *Bethlehem Globe-Times* building was expanded in 1929. In 1901, Warren A. Wilbur, president of E. P. Wilbur Trust Company, purchased the *South Bethlehem Globe* and merged it with the *Bethlehem Times* into the resultant *Bethlehem Globe-Times*. After years of covering the news of Bethlehem, it closed operations on November 4, 1991.

Three

FAITH

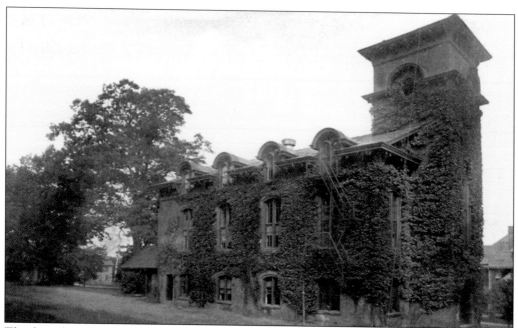

The first church building in South Bethlehem was erected by the Moravian congregation on Christmas Day 1864. Asa Packer had donated the property south of Packer Avenue to the Moravian congregation in 1862. They had just begun using it for services when Lehigh University trustees surveyed the property for the campus and purchased the building from the Moravians. They built a second church across the street two years later at Packer Avenue and Elm Street, now Webster. Lehigh University opened its first day of class on September 3, 1866, in what was named Christmas Hall. Eventually many other churches and religions would populate South Bethlehem.

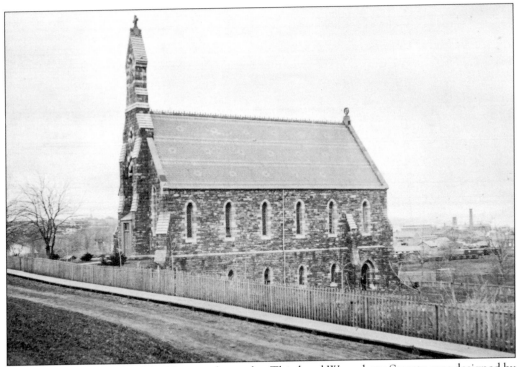

The Cathedral Church of the Nativity, located at Third and Wyandotte Streets, was designed by an ecclesiastical specialist, Edward Tuckerton Potter of New York, for the Episcopal congregation. The cornerstone for the church was laid on August 6, 1863. The church was erected in 1864–1865, but was in use by the congregation by December 1864. It was consecrated on the day of President Lincoln's funeral, April 19, 1865.

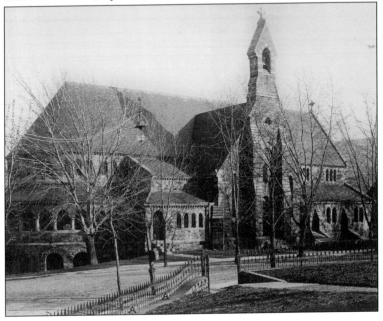

The Cathedral Church of the Nativity was enlarged in 1888 and the parish house added in 1897. All the buildings were constructed of quartzite stone. Indiana limestone and Pennsylvania blue sandstone were added for decorative elements. The contractor was J. S. Allam of South Bethlehem. The tall square bell tower was donated in 1907 by Warren A. Wilbur in memory of his late wife, Sallie Packer Linderman.

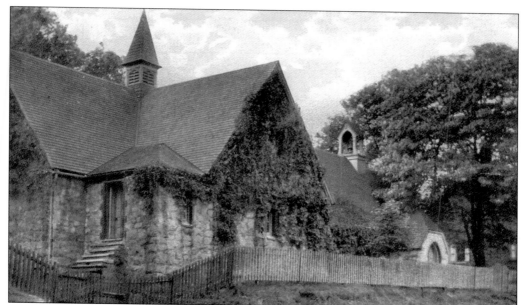

St. Joseph's Chapel (1884) was the place of worship at the east end of South Bethlehem for the Episcopal congregation. Years later, the vacant chapel was bought by St. Nicholas Greek Orthodox Church, where deceased members of both churches are interred in the cemetery in back of the church.

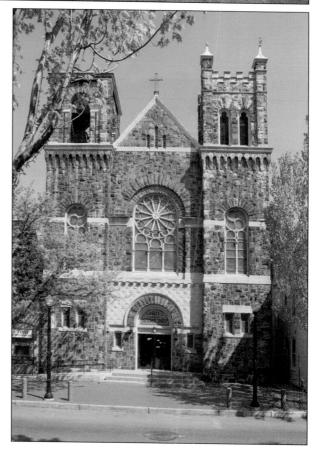

First Reformed Church, located on West Fourth Street, was to be erected in 1895, but lack of funding postponed work. Designed by architect A. W. Leh, with H. O. Trumbore as contractor, the church was completed in 1896 at a cost of $20,000. Beauty lies in its details and its asymmetry, making it an architectural gem on West Fourth Street.

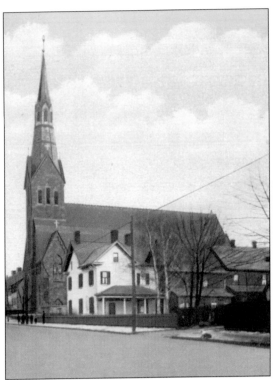

Holy Infancy was established as South Bethlehem's first Roman Catholic Church in 1867 for the primarily Irish congregation. The church that stands today was built in 1882 on the site of the original church. This Gothic Revival structure was inspired by the great ecclesiastical architect, Edwin Forrest Durang, who also designed the Academy of Music in Philadelphia.

St. John Capistrano Church, 910 East Fourth Street, was named after a Franciscan Friar of the 15th century. The church was founded in 1903 by 20 Hungarian men who resided in South Bethlehem. This was their third church, as the congregation grew rapidly. The facade featured a central tower, an ogee-shaped spire, and exterior gilt statuary. The church was closed in 2008 by the Diocese of Allentown.

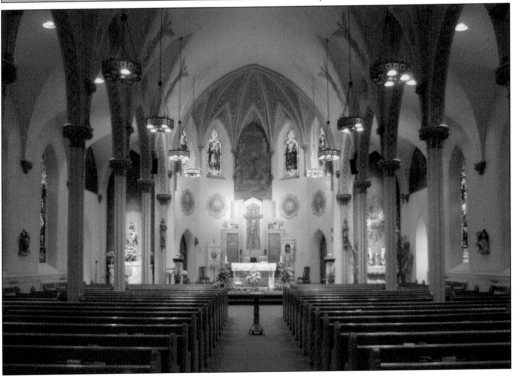

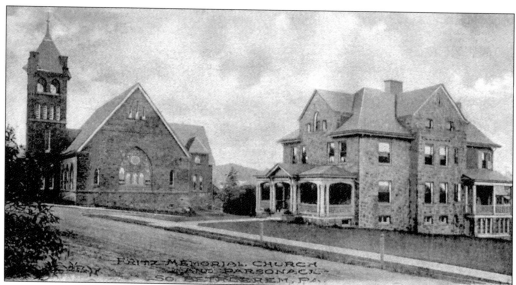

John Fritz, engineer for Bethlehem Steel, built the Fritz Memorial United Methodist Church at his own expense in honor of his mother. The church, built in 1893 at 303 Packer Avenue, was designed by architect A. W. Leh. The church's floor plan included a large auditorium space to serve as a lecture hall for religious education.

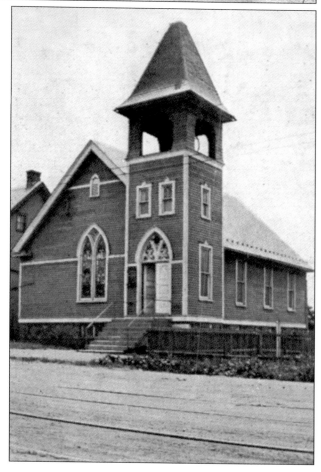

A meeting of nine people held in the home of A. L. Cope in 1888 led to the founding of the St. Mark's Evangelical Lutheran Church, located at 1526 East Fourth Street in Northampton Heights; it was dedicated on December 8, 1895. By 1937, more than 400 persons were listed as members. The church and its neighborhood were acquired and razed in 1968 by Bethlehem Steel to build a basic oxygen furnace.

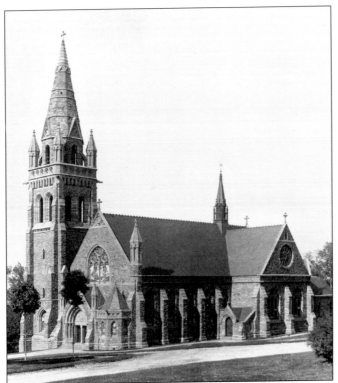

Lehigh University was founded in 1865 by Lehigh Valley Railroad magnate Asa Packer. Packer Memorial Chapel, built in 1887, was a gift to Lehigh University by his daughter, Mary Packer Cummings. Accented with a 125-foot spire, the Victorian Gothic structure was designed by architect Addison Hutton. It was dedicated on March 18, 1888.

On December 21, 1885, Fr. Bernard Korves purchased a plot of ground on Walnut Street, now Carlton. The first floor of the two-story building held the school; the second floor was for church services. The forerunner of Holy Ghost Roman Catholic Church, the structure was dedicated in 1888 and became St. Bernard Church. It was used as a social hall, renamed the Casino.

By 1910, Holy Ghost's main and side altars were built, and the Stations of the Cross, the communion rail, and the rose window in the sanctuary were installed. In 1962, the congregation repainted and regilded the entire sanctuary. In 1988, Holy Ghost celebrated its 100th anniversary as a parish in its present location. In 2008, Holy Ghost Church was renamed University Parish of Holy Ghost.

The interior architecture of Holy Ghost Church was designed in the Romanesque style and featured decorations and paintings executed by German artisans. The baldachino resided in the same position over the altar when first built. Statuary and interior columns and walls were brightly painted. The original stained-glass windows were exquisitely produced by Franz Meyer of Munich, Inc.

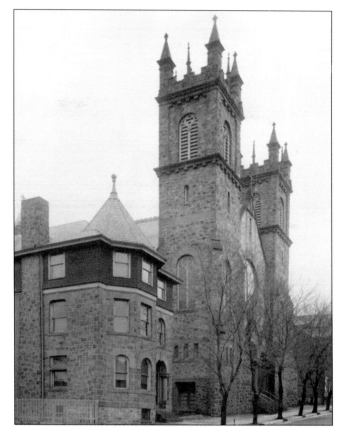

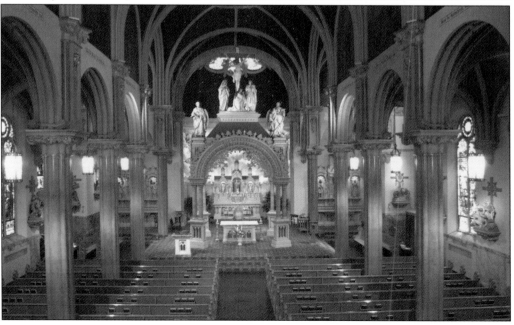

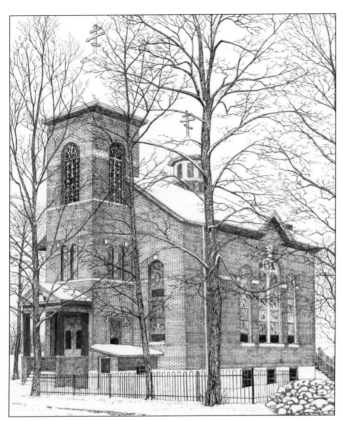

St. Nicholas Russian Orthodox Church, constructed between 1916 and 1917, was a 74-foot-by-42-foot brick edifice with a central tower and onion dome. Congregants were immigrants predominantly from Minsk, Grodno, and Volhynia. Builder William J. Heller donated five building lots on East Sixth Street in exchange for the contract to erect the church.

The Hungarian Reformed Kalvin Hall was located at 121 East Third Street. The First Hungarian Evangelical Reformed Church, built from 1911 to 1917, featured a brick veneer with an ashlar sandstone facade. Located at 520 East Fourth Street, the cornerstone of the congregation's present home bares the inscription "MAGYAR EV. REFORMED—1906–1917."

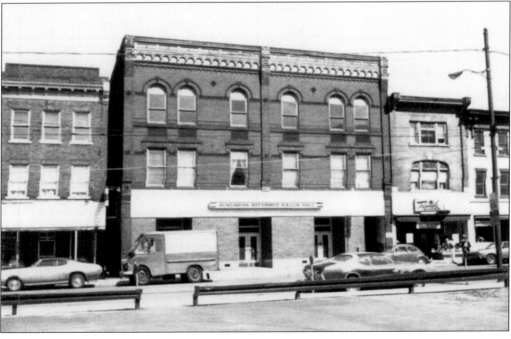

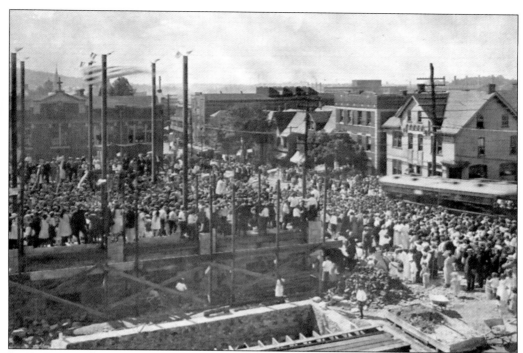

In 1916, groundbreaking commenced to build the St. John's Windish Lutheran Church on East Fourth Street. The congregation, which comprised of Wends, emigrated from Slovenia in the vicinity of Austria-Hungary and Yugoslavia.

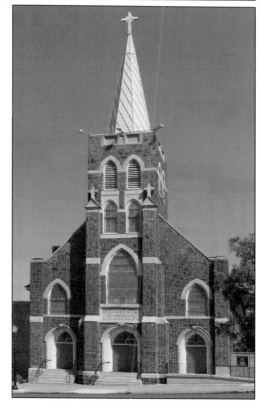

Built in 1909 by contractor Benedict Birkel, St. John's Windish Lutheran Church celebrated its 100th anniversary in 2009. In 1916, the congregation installed an M. P. Moeller Company organ, which consisted of 12 ranks with 689 pipes. St. John's still serves the community at its East Fourth Street location.

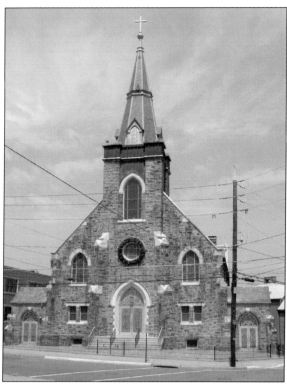

SS. Cyril and Methodius Roman Catholic Church was founded by Slovak immigrants. Their second church was designed by architect A. W. Leh and was constructed in 1906 by Benedict H. Birkel. Located at 617 Linden Street, now Pierce, the tall pinnacles and spire dominate the landscape. In 2008, the Allentown Diocese renamed the parish Incarnation of Our Lord.

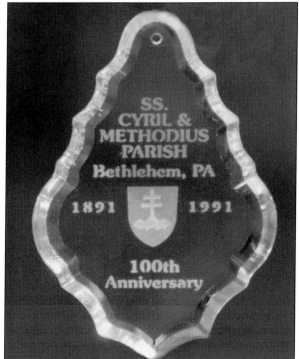

In 1991, the parishioners of SS. Cyril and Methodius Church celebrated their 100th anniversary. They gathered at Stabler Arena to dance the night away on June 30, 1990. A souvenir book was published and a keepsake given to mark the occasion.

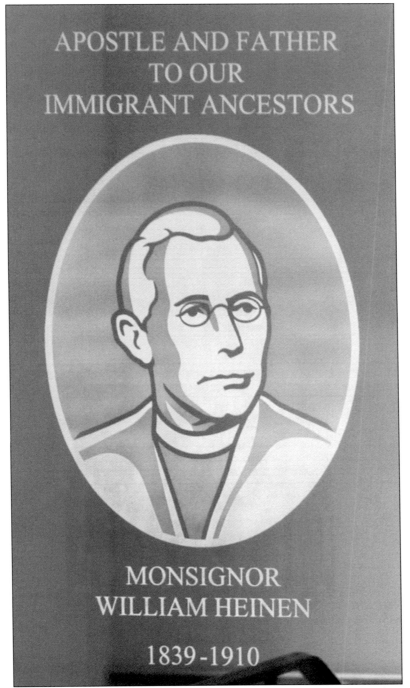

APOSTLE AND FATHER
TO OUR
IMMIGRANT ANCESTORS

MONSIGNOR
WILLIAM HEINEN

1839-1910

This glass etching was donated to SS. Cyril and Methodius Church by Matthew and Mary Stofanak. Arriving in the Lehigh Valley in 1872, Msgr. William Heinen helped to organize immigrant parishes in Northampton and Carbon Counties. The first church he organized in South Bethlehem was SS. Cyril and Methodius.

St. Stanislaus Roman Catholic Church, located at 429 Hayes Street, was built by Polish immigrants in 1906. As parishioners died or moved beyond their old neighborhood, support to operate the parish dwindled; these unfortunate consequences forced the Diocese of Allentown to close the church in 2008.

A photograph illustrates the bottom of a chalice from St. Stanislaus Church. The chalice, an important vessel for the Sacrifice of the Mass, bears the inscription, "St. Stanislaus Polish R. C. Church So. Bethlehem, Pa." The inscription indicates the chalice was used prior to South Bethlehem's unification as one city with Bethlehem in 1918.

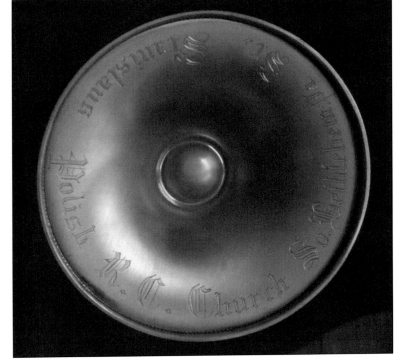

St. Joseph's Roman Catholic Church at 415 East Fifth Street was founded by Slovenian immigrants in 1913 who evolved from of a group of Slovenian Catholics who worshipped at Holy Infancy Church prior to the founding of their own church. The cornerstone indicates the congregation as Windish, a controversial and debated topic describing the ethnic heritage of this group.

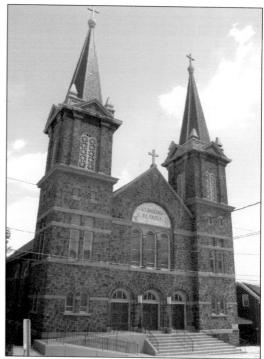

In the fall of 1916, the basement of the church was consecrated for worship; the upper church was completed in 1917 under the direction of contractor Benedict H. Birkel. The church's exterior Romanesque style possessed distinctive double steeples. The sanctuary, designed in the characteristic neo-baroque, was an architectural style favored by Roman Catholics in regions of southern Europe. The Allentown Diocese closed the parish church in 2008.

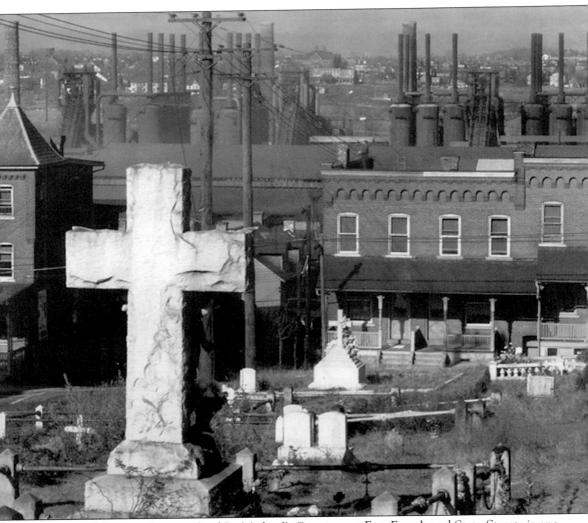

This well-known photograph of St. Michael's Cemetery at East Fourth and State Streets is one of many views of South Bethlehem taken by photographer Walker Evans during the years of the Great Depression.

Four

HOPE

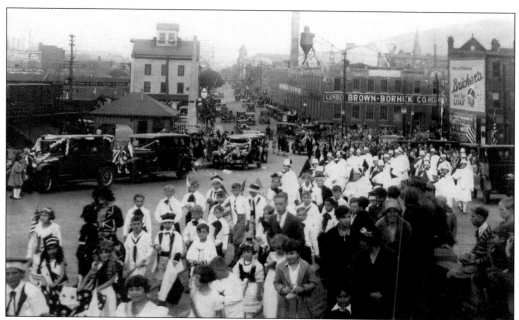

An ethnic parade takes the Hill to Hill Bridge ramp on Pulaski Day during the 1930s. A trek across the bridge sent them past the old Brown-Borhek wood mill on West Third Street and Brodhead Avenue. The Comfort Suites is located on the site today.

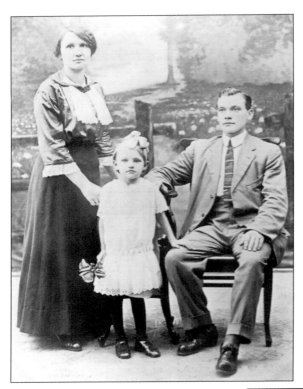

The family posing is, from left to right, Babcia Katarzyna Bentkowski, granddaughter Ciocia Mary Wieczorek, and Dziadek Piotr Bentkowski. The grandparents took care of little Ciocia as her parents worked. The photograph was taken between 1910 and 1915.

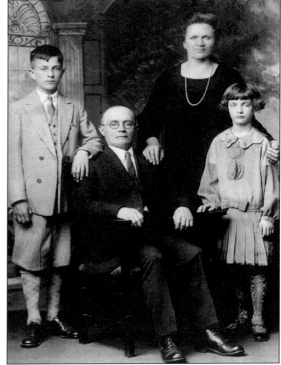

Charles Klein (left) stands next to his father, John; his mother, Katherine; and his sister, Elsie. Charles would become principal of Liberty High School as an adult.

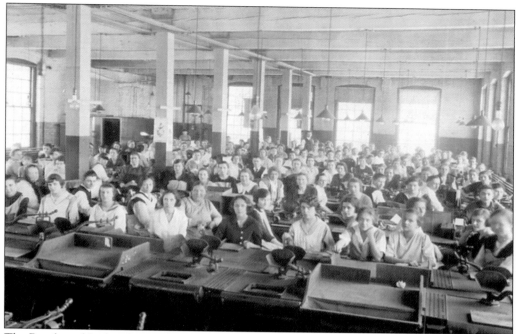

The Bondy and Lederer's cigar factory, located at the corner of Evans and Pierce Streets, employed young women who were paid less than men. It was difficult work, and the women suffered nicotine poisoning when their hands became stained. The photograph was taken in 1912.

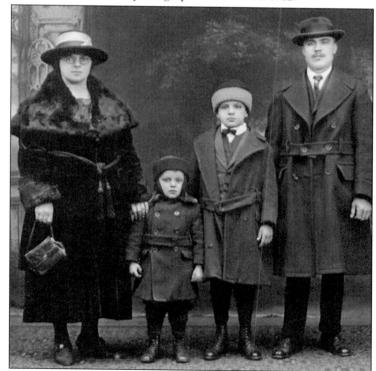

A family poses for a photograph dressed in winter coats around the 1930s. Showing they could afford new clothes, photographs like these of the well dressed were sent to families still living in Europe, proving that living in America was worth leaving their European villages.

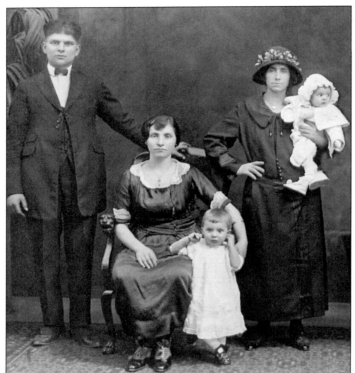

After safely surviving World War I, Patsy Cappelli stands next to his wife, Julia, who has her arm around their daughter, Yolanda, while a relative holds their younger daughter, Armeda. In time, the girls would lose both parents to early deaths.

Standing on Mechanic Street in 1941, Joseph and his wife, Josephine Gemelli, from the Bronx, New York, visit their godson, Frank Bellizzi (in the car). Kneeling below, from left to right, are sisters Yoland and Armeda Cappelli, Frank Bellizzi Sr., Isabella, and her husband, Frank Pacinelli. After the Cappelli girls lost their parents at an early age, the Pacinellis raised the girls as their own.

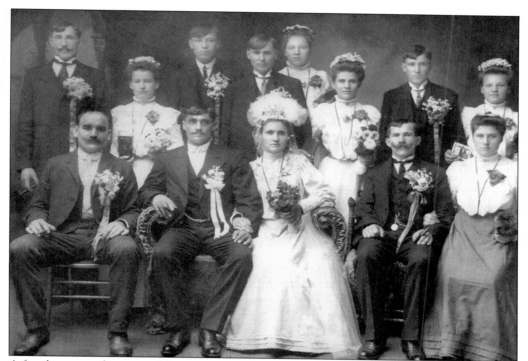

A family surrounds a young Hungarian couple at their wedding. The value of clean, new clothes and shoes worn only on Sunday adds a sense of success to these immigrant workers who labored in South Bethlehem mills and factories.

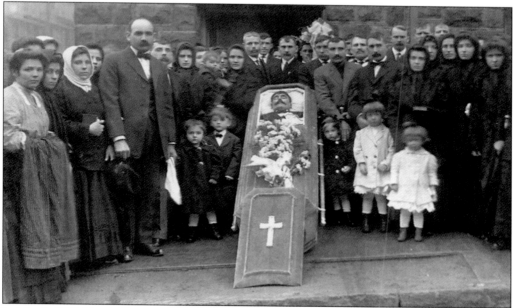

In March 1912, Karoly Doncsescz stands behind her husband's coffin holding their infant child. It is believed photographs were sometimes taken as a memorial so family back in Europe could be informed of the death. A procession on foot would lead to St. Michael's Cemetery, where he was buried.

Immigrants arriving in South Bethlehem brought music and cultural traditions from their native lands. A famous local Hungarian singer was Frank Mikisits, who recorded songs fellow Hungarians enjoyed hearing.

The variety of nationalities living in South Bethlehem became evident during holidays, feast days, and celebrations that required music for dancing and singing. In 1914, this Croatian string band created distinctive music reminiscent of their homeland.

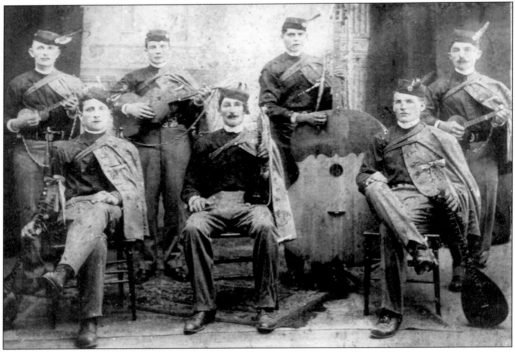

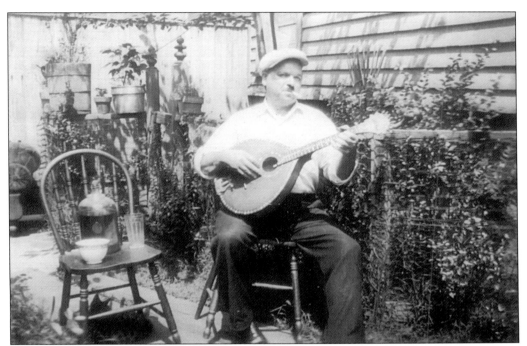

Portuguese immigrant Antonio Joaquin Sousa was born in Portugal in 1891. He played a 12-string Portuguese guitar in the backyard of his residence on Evans Street.

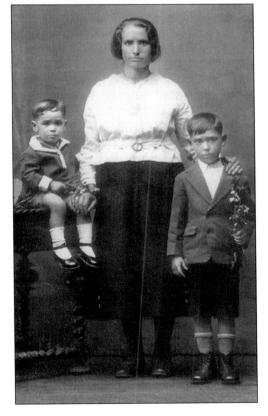

Teresa Pereira Sousa, with sons Armindo (left) and Antonio Jr., lived in Portugal from the time she married Antonio in 1926 until 1947, when the family emigrated and joined her husband in South Bethlehem.

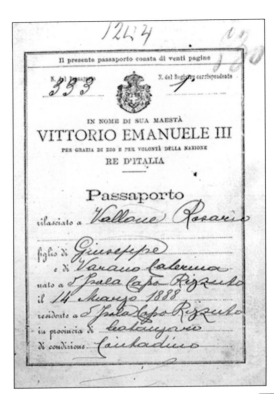

As with all immigrants coming to South Bethlehem from Europe during the early 20th century, a passport was needed to enter the United States. This passport belonged to Italian immigrant Rosario Vallone. His parents were Giuseppe (Joseph) and Caterina (Catherine) Varano. As was the custom, Italian women, whether married or not, retained their maiden names on official documents.

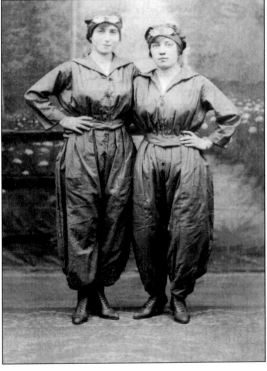

Italian immigrant Elizabeth Pontecorvo (right) and her friend are attired in outfits worn while they worked at the Reddington munitions plant during World War I. Trousers allowed women mobility, while the bottoms were tied around their ankles so the material would not catch on anything to accidently detonate the shells or ammunition.

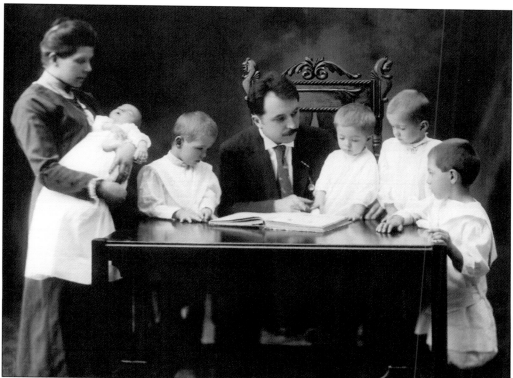

The Biro family, pictured from left to right, are Gizella Gulyassy Biro holding infant daughter Piroska, Francis, Frank Biro, Margaret, Gizella, and Zoltan. Frank Biro and Gizella Gulyassy met in South Bethlehem after emigrating from different regions of Hungary. Frank opened a photography studio where he took countless photographs of immigrants of South Bethlehem.

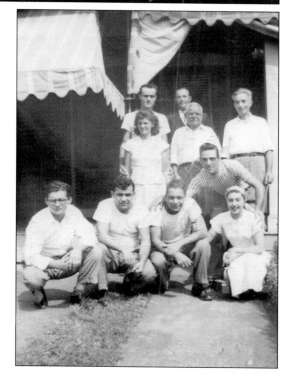

Pictured from left to right are (first row) Bellizzi brothers Carmeno, Joe, and Frank Jr., and Joe Raniere and his niece Cathy Gemelli; (second row) Yolanda Santoro, Frank Bellizzi Sr., and Frank Pacinelli; (third row) Yolanda's husband, Joe Santoro, and Joe Gemelli. The occasion was the 1950 marriage of Carmeno to his bride, Catherine Lavinger, both of whom would operate Carmen's tailor shop. Joe Santoro's son, Joe Jr., would become principal of Broughal Middle School, and Joe Raniere would work at Moravian College.

Italian immigrants Elizabeth Pontecorvo and Rosario (Russell) Vallone met in South Bethlehem and were married. They opened Rosario's Grocery Store on 204 Mechanic Street in 1926, but the Depression forced them to close and find other work.

At the Mar wedding in 1927, the bridesmaids wore pink dresses with black hats. The flower girls' dresses were rainbow chiffon with gold.

The Long family, pictured from left to right, are (seated) Eva, Joseph, and John; (standing) Mary, Henry, Otto, Harry, Joe, and Willie. John Long operated Long's Bakery on Bradley Street across from the slaughterhouse.

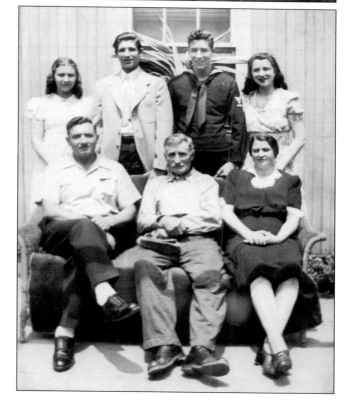

This 1943 photograph of the Pondelek family was taken in Hellertown, Pennsylvania. They are, from left to right, (first row) Frank Pondelek, James Ceban, and Elizabeth (Ceban) Pondelek; (second row) Pearl, Alfred, James, and Dolly. Pearl Pondelek would go on to operate Pondelek's Greenhouse in Hellertown after working at her father's butcher shop in South Bethlehem.

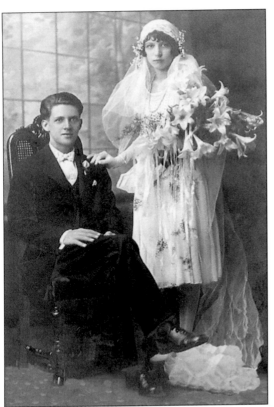

John and Caroline Mies are seen on their wedding day. John emigrated from Alsace Lorraine. Their son, John B. Mies, would marry Angella Hoffstetter and raise a family. John Jr. worked at Bethlehem Steel for 45 years and achieved the dream of owning a Chrysler.

In 1897, Michael Volk (standing at right) operated a boardinghouse for steel workers near Hayes Street and Daly Avenue in South Bethlehem. His daughter, Stella (on the porch, left), stands near her mother, Theresa Volk. Stella would eventually marry Patrick A. Ferry and raise seven children.

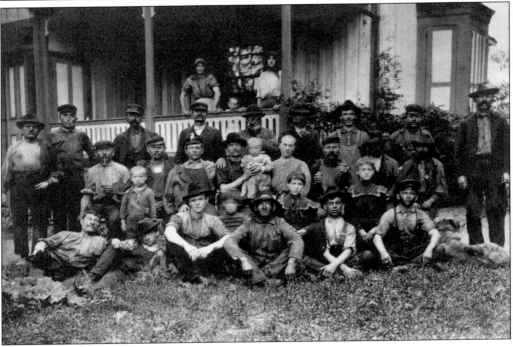

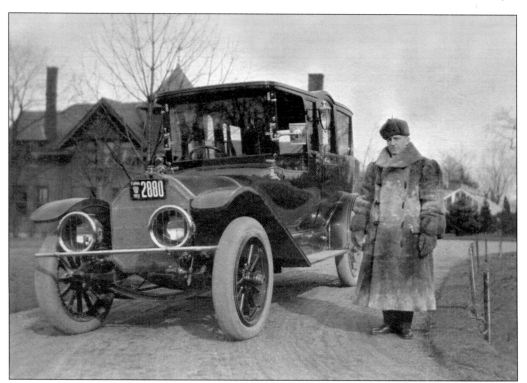

George Weaver was the chauffeur for Warren A. Wilbur, president of E. P. Wilbur Trust Company in South Bethlehem. Warren's garage, seen at left, was originally a stable in 1892 to house horses and a carriage for the Wilburs.

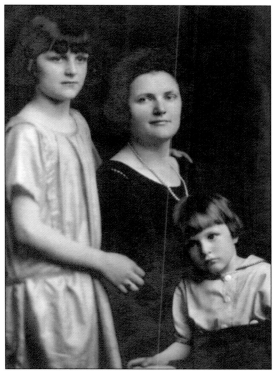

Sarah McNamara Weaver poses with her children, Dorothy (left) and Merritt (right). While single, Sarah worked in Warren A. Wilbur's mansion on West Third Street as a second-floor maid. There she met her future husband, chauffeur George Weaver. They were married and lived on Cherokee Street, where they raised their two children.

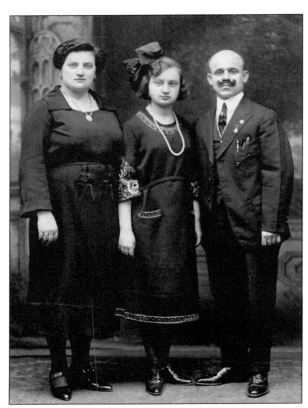

Magdalena Szabo (center) was one of four daughters and the mother of the late Bethlehem councilwoman Maggie Szabo.

The Bankowski's wedding included a small representation of the wedding party, but those present still sent best wishes for the couple's happiness as if there were a multitude.

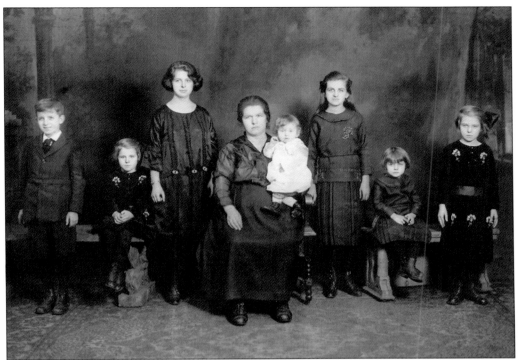

Lined up for a family portrait in 1922, the Samu family waits patiently for the shutter to click. From left to right, family members are Joseph, Mary, Rose, Gizzela, William, Ethel, Margaret, and Gizzela.

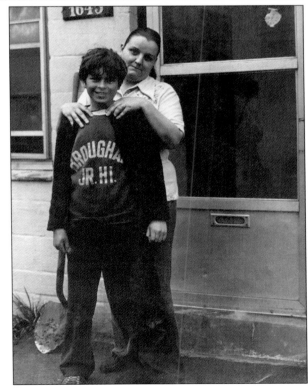

At their 1645 East Twelfth Street home in the South Terrace housing project, William Rivera proudly wears a Broughal Junior High sweatshirt while standing in front of his mother, Sandra.

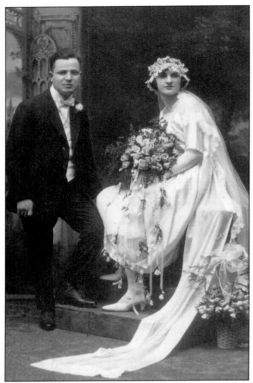

A remarkable aspect of Placido Cantelmi's life was his faith and hope in his sons' success, whatever jobs they chose. He arrived in South Bethlehem an Italian immigrant and assumed the nickname "Patsy." He married his wife, Julia, and raised their two children, Louie and Geraldine. Patsy opened Cantelmi's Hardware Store in South Bethlehem.

While the Cantelmi children, Louie and Geraldine, were young, their mother, Julia, suddenly died. As an adult, Louie followed his father's profession and would own and operate Cantelmi's Hardware Store for the rest of his life. In time, the hardware business interested his son, Rick, who now assumes ownership.

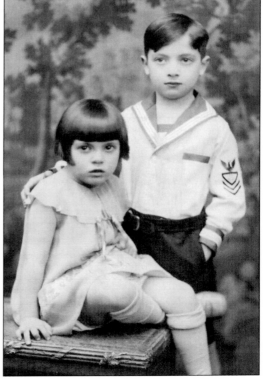

Patsy's second wife, Isabella, was not only mother to Louie and Geraldine, but also to their own twins, Dino and Isabella. Soon the house was full with four growing children.

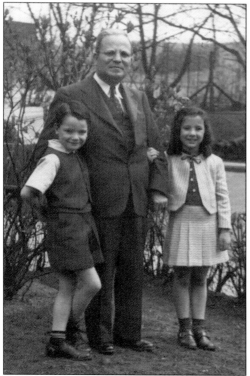

Dino and Isabella are seen here with their father, Patsy. As an adult, Dino studied the undertaking business, which he opened on East Packer Avenue across from Lehigh University. Eventually Dino moved his establishment to Fountain Hill on Broadway, where his own son, Dino Jr., followed his father's profession.

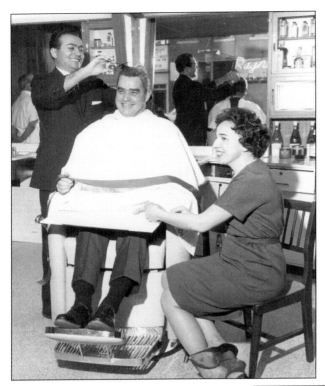

Ragni's Barbershop is pictured in 1963. Tony Ragni and his wife, Madeline, attend to Mayor Gordon Payrow. Tony was known for his lightning-fast, yet high-quality haircuts. The barbershop was a fixture in South Bethlehem for 40 years, until the couple passed away in 2005.

William and Gertrude Herbst Trumbore lived at 452 Carlton Avenue in half a double house. William was the youngest son of Henry Ott Trumbore, a contractor who built about a dozen residences on Carlton Avenue.

Five

HEALTH AND EDUCATION

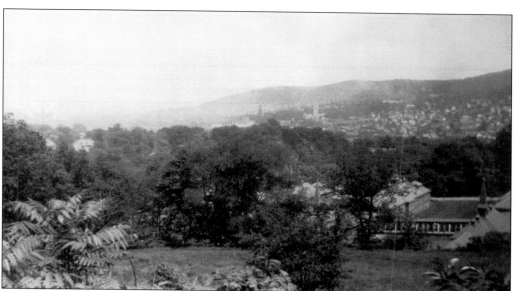

This view of St. Luke's Hospital was taken from the reservoir on the eastern slope of Fountain Hill. Dr. Francis Henry Oppelt purchased 2 acres in 1846 from the Moravians to build his Hydropathic Institute, more commonly called the Water Cure. In 1871, Oppelt lost the property to a sheriff sale. Tinsley Jeter purchased it and sold it to Asa Packer. Packer then offered it to the directors of St. Luke's Hospital, who were in need of a larger facility.

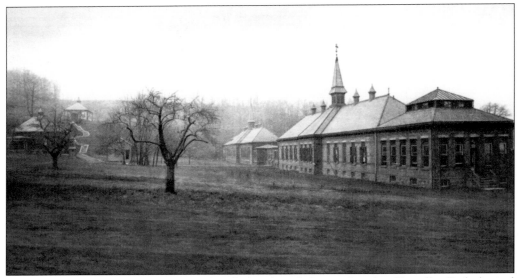

This early view of St. Luke's Hospital includes, from left to right, the Chandler Pathological Laboratory, the Student Pavilion, Sayre Ward, and the Children's Ward, later named the Merritt Wilbur Pavilion.

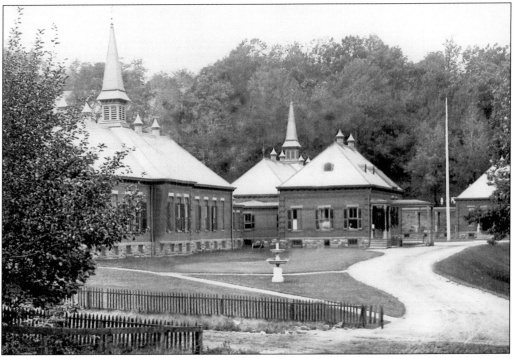

The first patients occupied the old Water Cure building on May 24, 1876. In the year 1877, the hospital took in 108 cases, and by 1878, the hospital had 19 beds. When Judge Asa Packer's will was probated in 1879, he had provided the hospital with $300,000 a year to pay the expenses of any employee working on the Lehigh Valley Railroad. Remaining revenue from the bequest could go to general hospital expenses.

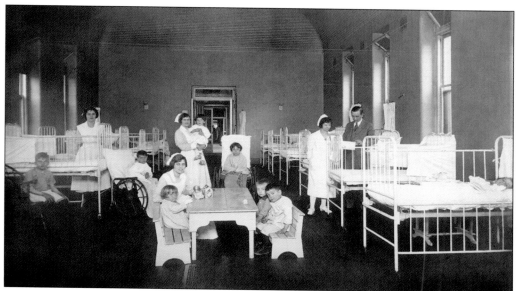

In 1890, E. P. Wilbur donated the children's pavilion of St. Luke's Hospital in memory of his son, Merritt Abbott. At that time, the hospital was designed as a series of wards or pavilions for women, men, and children. Today all that remains of these original wards is the Coxe Pavilion, which has been restored as a museum.

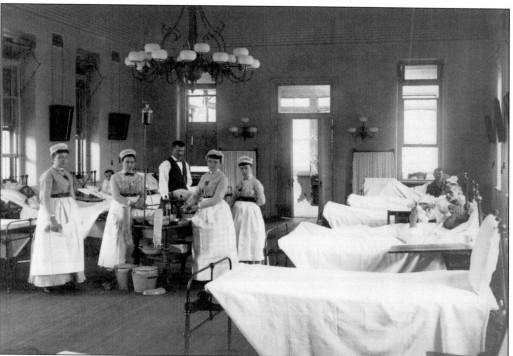

Shown here is the men's ward. M. J. Merritt set up a school of nursing at St. Luke's Hospital in 1885 in the tradition of Bellevue Hospital in New York. Nurses in this photograph were trained over a two-year period.

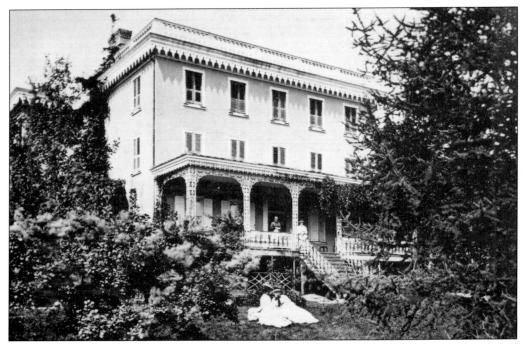

In 1850, Charles Augustus Fiot purchased Charles Tombler's 108-acre property. He beautified the estate and named it Fontainebleau. Tinsley Jeter purchased the estate in 1866. Bishopthorpe Manor, a boarding school for girls, was opened in 1868 in the Fiot mansion. In 1931, the building became the residence of the St. Luke's student nurses.

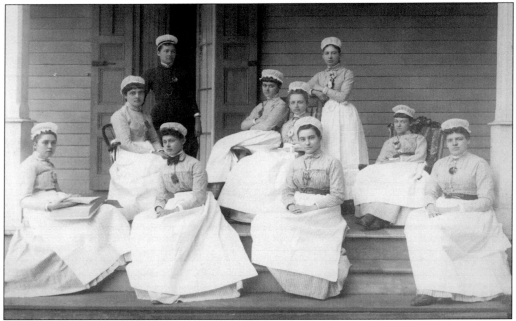

St. Luke's first School of Nursing graduates of 1885 sit on the steps of their residence house. They are wearing the white organdy Bellevue cap.

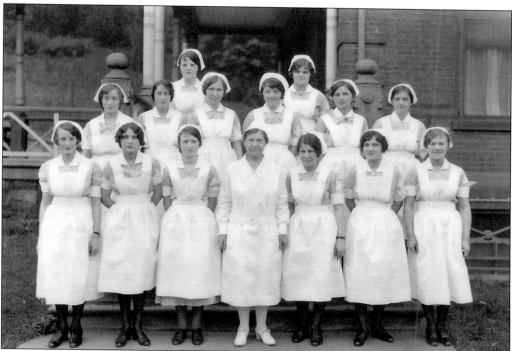

St. Luke's nurses, in 1928, wore black stockings and black oxfords before graduation.

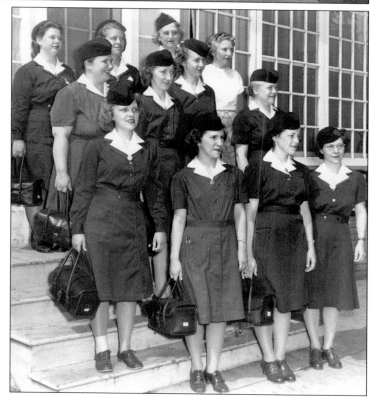

In 1947, the St. Luke's Visiting Nurses are ready to visit patients living in the Bethlehem area. The group started in 1919 and, over 90 years later, still provide a vital service to the community.

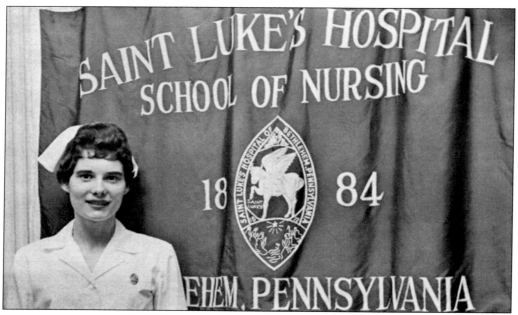

SAINT LUKE'S HOSPITAL
SCHOOL OF NURSING
18 84
EHEM, PENNSYLVANIA

PATIENT'S COPY

ST. LUKE'S HOSPITAL

BETHLEHEM, PA.
PHONE
AREA 215 - 867-3991

— CASH RECEIPT —

CASHIER DATE 5-6-68 196

RECEIVED OF
FOR PATIENT *Mrs Alice Small* CODE
 FILE NO. 152653

ADDRESS CITY

CASH		CHECK	X	M.O.		

MAY -6 A I -CASH AMOUNT RECEIVED $ *126.00* * 126.00 *

CLASSIFICATION	AMOUNT	CLASSIFICATION	AMOUNT
PRIVATE	$ *126 00*	CRUTCHES	$
SEMI-PRIVATE	$	P. R. CHEST	$
WARD PAY	$	X-RAY THERAPY	$
WARD PT. PAY	$	NUCLEAR MED.	$
EMERGENCY	$	CAST ROOM	$
CLINIC	$	OPER. ROOM	$
DRUGS	$	ANESTHESIA	$
LABORATORY	$		$
X-RAY	$		$
TECH. LAB.	$		$
PHYS. MED.	$		$
MISC.			$

00550 RECEIVED BY *H Kelly*

ST. LUKE'S HOSPITAL

PAPER PATENTED BY N. C. R. CO. DATED INCORPORATED

In 2009, St. Luke's School of Nursing celebrated its 125th anniversary as the oldest hospital-based diploma school in continuous operation.

Alice Small received this bill from St. Luke's Hospital for her hospitalization in 1968. Her total amount owed was $126 for her treatment.

Bishopthorpe girls enjoy social time with Lehigh boys in a park near the reservoir above St. Luke's Hospital around 1909. Henrietta Caproni (center, near the pole), was sweet on Chester Lawson (right).

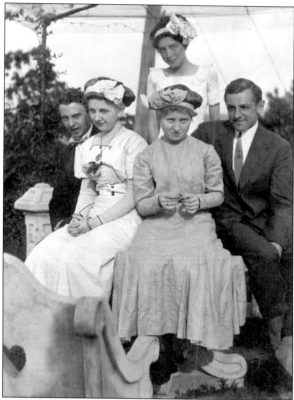

On the grounds of Bishopthorpe School for Girls, female students take a break from tennis with Lehigh boys. Social gatherings were encouraged on weekends as a means of getting away from the rigors of lectures and homework.

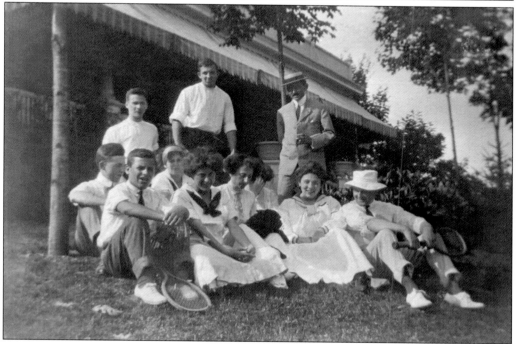

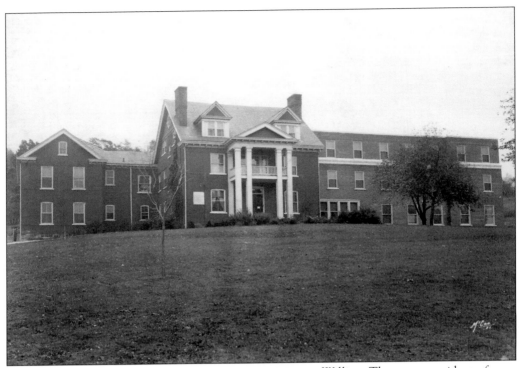

William Thurston, president of Bethlehem Iron Company, initiated the concept of a children's home for orphaned survivors of the smallpox epidemic of 1882. Pictured above is the third children's home, designed by A. W. Leh in late 1895. Capt. James Wiley made a generous personal donation for this home with the condition that it be named in honor of his wife, Annie Lewis Wiley.

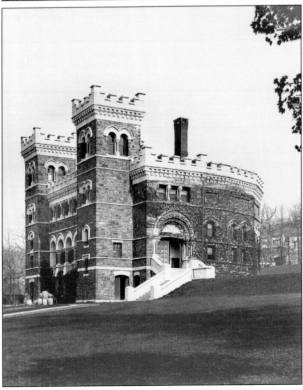

This is the Lehigh University Linderman Library. Asa Packer endowed $500,000 to build a library and purchase books. Addison Hutton designed Linderman Library in memory of Packer's daughter, Lucy Packer Linderman. The library was completed in 1877 with an addition constructed in 1929.

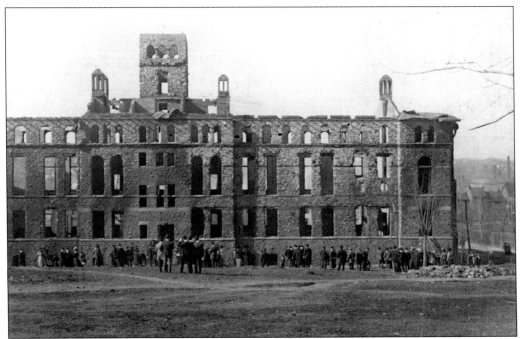

On April 6, 1900, Lehigh University's Physical Laboratory burned, leaving an empty shell. As Professor Franklin attempted to photograph a spark created with flash powder, the fire ignited. The Protection Hose Company delayed in arriving with firefighting equipment as they searched for a horse. Unfortunately they were too late, and the building was completely destroyed.

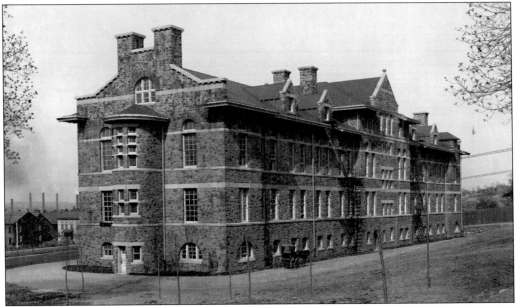

Later named the William Deming Lewis Laboratory for Lehigh University's 10th president, the lab was redesigned in 1900 by A. W. Leh and his former apprentice, Herman Schneider. Fireproof material, such as steel support posts, was incorporated and used again in later projects.

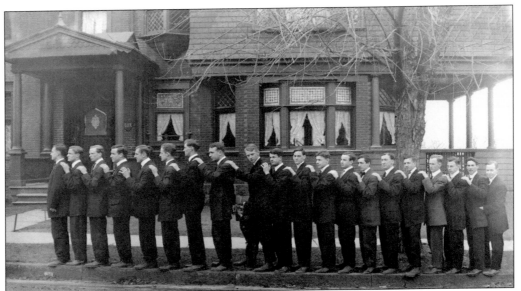

Lehigh fraternity brothers of the Theta Delta Chi house ham it up with their little black terrier mascot. Traditionally, many Leigh University fraternity houses lined the avenue throughout the 20th century; this one was razed in the 1920s.

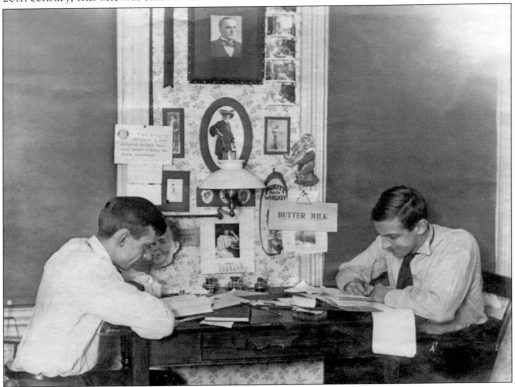

Fraternity brothers study in their room at Theta Delta Chi. Their bulletin board reflects notions and products of the year, around 1908.

Andrew Carnegie (1835–1919) visits
Lehigh University. He founded
the Carnegie Steel Company in
the 1870s. It became the largest
industrial enterprise in the world.
In 1897, Charles M. Schwab became
president. Schwab negotiated the
sale of Carnegie Steel to a group of
investors led by J. P. Morgan. The U.S.
Steel Company was formed through
the sale. Schwab was president of
U.S. Steel for two years, until he left
in 1903 to run Bethlehem Steel.

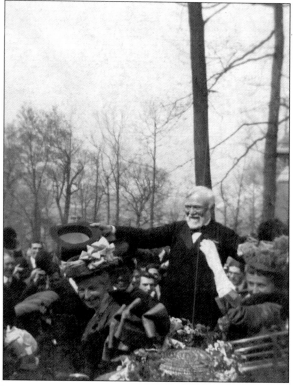

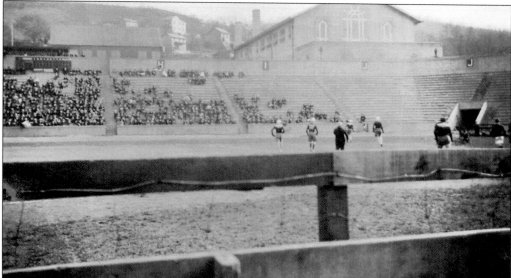

The photograph above shows Lehigh University's Taylor Stadium (1915–1988) during a Lehigh/ Lafayette game. In 1884, football coaches Theodore L. Welles of Lafayette and Richard Harding Davis of Lehigh organized the first ever match between the two teams. The rivalry is still going strong today. Lehigh received a gift from Emma Dinkey Schwab to complete the building of the stadium. It was named after former Lehigh graduate Charles L. Taylor.

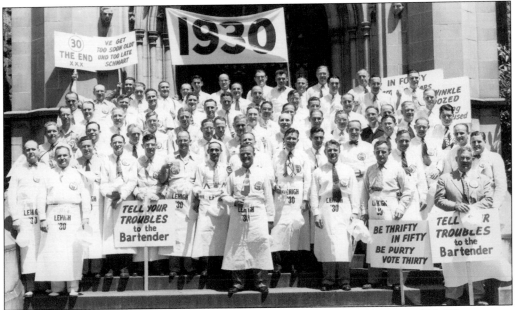

This group of Lehigh University alumni is flaunting their glasses of beer in 1930. They appear not to support the 18th Amendment to the United States Constitution, which was Prohibition (1919–1930), the ban on the sale, manufacture, and transportation of alcohol.

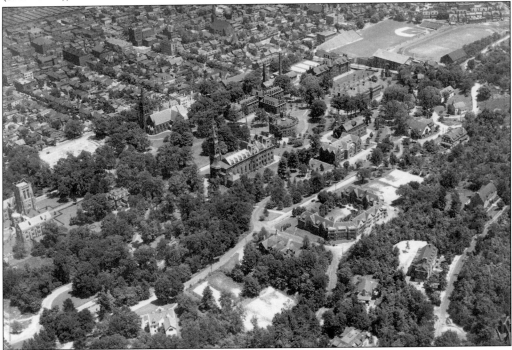

Here is a view of the neighborhood south of Packer Avenue. The photograph was taken before 1967, when Lehigh University maneuvered their "Packer Avenue Project." Four blocks of homes, including the home of former mayor Robert Pfeifle, were demolished to make way for new campus buildings.

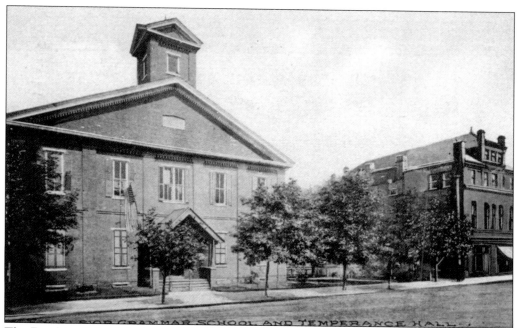

The Excelsior School, built in 1879 for $17,100, offered a four-year high school program for the first time to South Bethlehem students. It was located on Fourth Street, between Adams and Webster Streets, and served as a high school from 1879 to 1892. When the Central School was completed in 1892 on the site of the old Penrose School, the high school program was moved to that building. Next, the South Bethlehem High School opened in 1918 at Packer Avenue between Vine Street and Brodhead Avenue. Liberty High School, opened in 1922, and Freedom High School, opened in 1967, now serve all the high school students of Bethlehem.

The Webster School, pictured here, was built in 1889 at a cost of $24,000. It was an eight-room brick structure situated on the east side of Carlton Avenue, south of Packer Avenue and north of Broadway. It no longer stands.

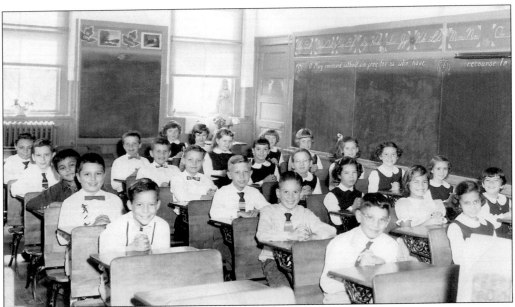

Holy Infancy Parochial School students are seated at stationary desks in their classroom in 1957. Pictured are, from front to back, (first row) Raymond Confer, Donald Peters, Carlos Gonzalez, Thomas Nolan, and Anthony Altenbach; (second row) Roy Urello, Robert Gasdaska, Edward Narlesky, Samuel Westwood, Robert Makosky, and Michael Gillen; (third row) Anita Gonzales, Gloria Martinez, Cynthia Riccaboni, Joanne Carchio, Penny De Crosta, Marcella Reagan, Elizabeth Pinter, and Josephine Ruyak; (fourth row) Diane Ford, Rosemary Skomitz, Judith Foley, Patricia McAndrew, Margaret O'Donnell, and Anne Marie Cooke.

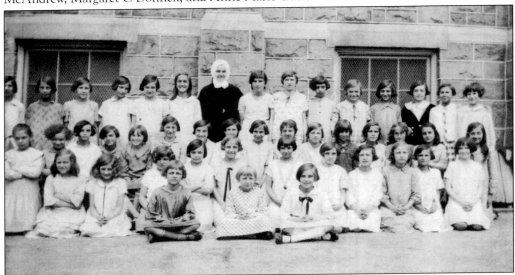

St. John Capistrano Parochial School, located at 902 East Fourth Street, was established in 1903 and served Hungarian immigrants in South Bethlehem. On July 4, 1910, a two-story brick school was dedicated. By 1920, five German and Hungarian teaching nuns, Daughters of Divine Charity, emigrated from Vienna with Rev. Mother Koszka Bauer to the school. Shown above is a fifth-grade class in 1926.

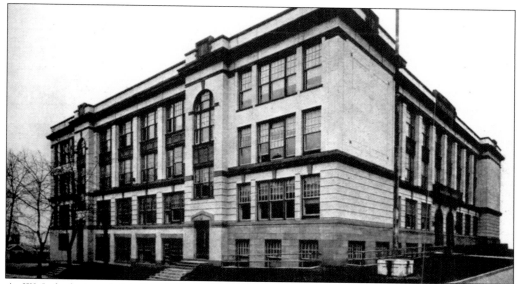

A. W. Leh designed this South Bethlehem High School, later known as the Broughal School. It was a four-story, 114,000-square-foot building in the Italian Renaissance style. It was built in 1915–1916 on 4.2 acres on the corner of Brodhead Street and Packer Avenue. The floors were laid with Terrazzo tiles. It had a pit-type gymnasium with a capacity for 500 spectators. The first-floor, center-of-building auditorium had a seating capacity of 1,300.

Here is a photograph of the first graduating class from the high school in the Penrose School in 1876. Pictured from left to right are (front row) Sallie Peysert, Mary Ulrick, James McMahon, Bernard Byrnes, and unidentified; (second row) Catherine Fluck (Christine) and Prof. H. S. Housekeeper, the principal; (third row) Margaret Coleman, Thomas Ganey, Mary E. Quinn (O'Reilly), John Held, Ellie O'Donnell, Hiram Danenhower, Bridget Daily, and Thomas M. Eynon.

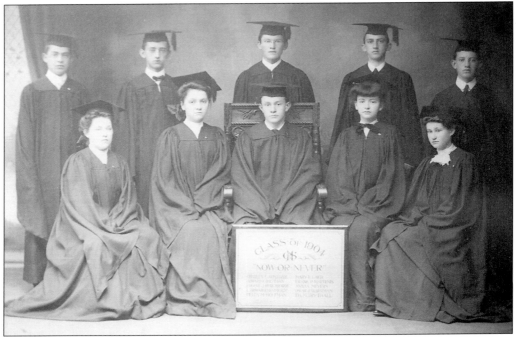

Above is the graduating class for Central High School in 1904. Unlike Penrose Schoolhouse, which was in deplorable condition and ready to collapse, Central remained well beyond the new high school building took its place.

The South Bethlehem High School name was changed to Broughal Junior High in 1933 in honor of Lawrence Broughal, pictured at left, a former school board member. A 1937 study of the Bethlehem School District reported that Broughal served as a junior high school (grades 7–10) and as a trade and industrial high school (grades 7–12). An addition of 10,000 square feet was completed in 1961.

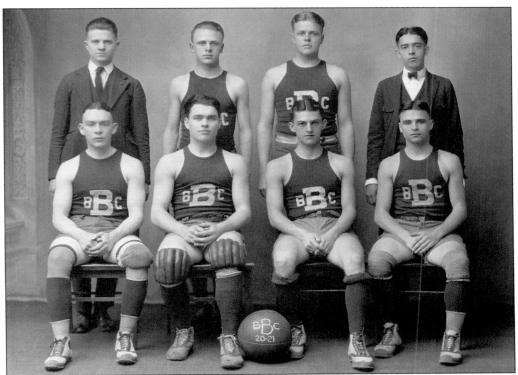

Here is the Bethlehem Basketball Club team of 1920–1921. There were hundreds of men's basketball teams throughout the United States in the 1920s. Before the widespread convenience of watching televised professional sports, the community would come out to see local sports teams play.

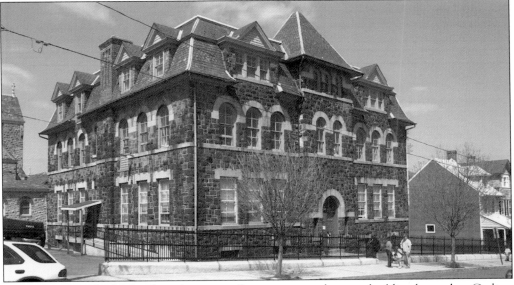

Holy Ghost Parochial School is a three-story, Romanesque-style, stone building located on Carlton Avenue. It was designed by A. W. Leh and completed in 1900. Holy Child in Fountain Hill was formed in 1982 by the merger of St. Ursula and Holy Ghost Schools.

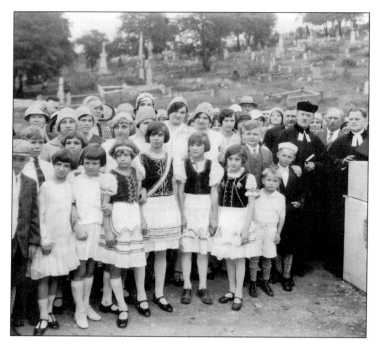

Youngsters eagerly witness laying the cornerstone of the Zion First Hungarian Lutheran Church at the corner of East Fourth and State Streets on June 30, 1929. The girls in the front row, from left to right, are Irene Sancza, Yolan Mar, Olga Bujcs, Sophie Szalay, Vilma Csongeto, and an unidentified girl. The two tall girls in the center are Elizabeth and Mary Meszaros. Louie Hegedus stands next to Steve Mar wearing a sailor hat. On the right, Steve Horvath stands between Reverend Pottschacher and Reverend Stiegler.

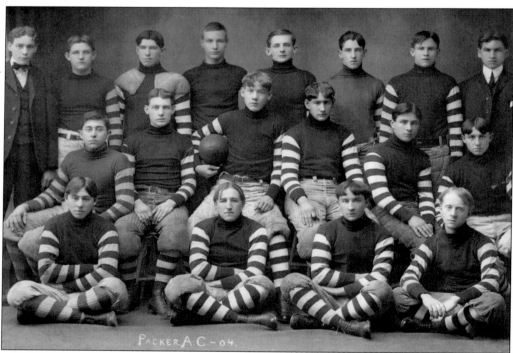

PACKER A.C. - 04.

Seated in the front row, second from the left, George Weaver enjoyed a rough-and-tumble game of football with the Packer Athletic Club in spite of the dangers of getting seriously injured. Physically fit, George went on to take a chauffeur job and met his future wife, an Irish maid named Sarah McNamara, in Fountain Hill.

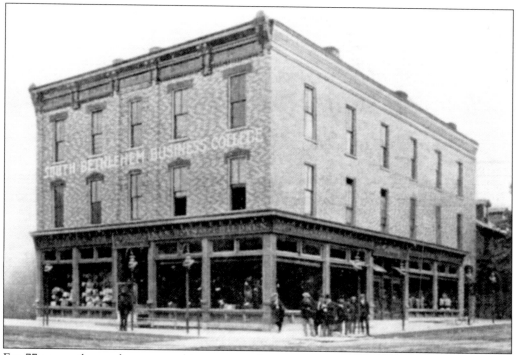

For 77 years, those who were seeking an expedient course in business training could find an excellent program at the South Bethlehem Business College. This was the first home of the school, above the O'Reilly's Clothing Store, on the corner of Third and New Streets.

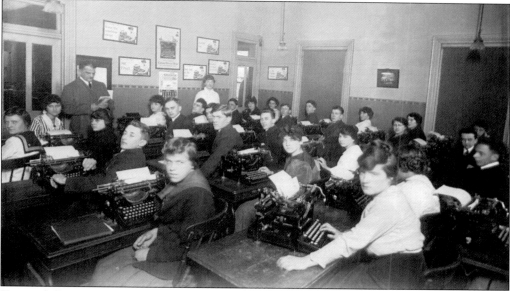

Typing skills were the prime mechanical skills needed to become a business administrator in 1915. Other training at the South Bethlehem Business College consisted of stenography, accounting, and secretarial duties. William F. Magee, owner of the college, shaped the curriculum around the needs of the individual student, a concept that has become popular today.

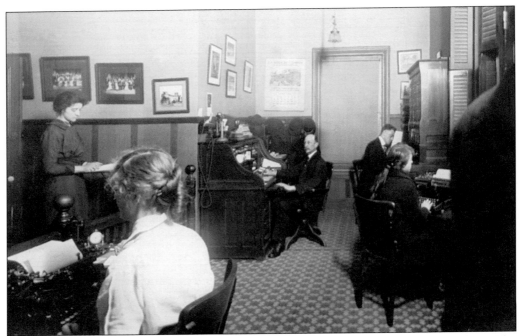

Above is a photograph of the business office of the South Bethlehem Business College. The combination of good teachers, hardworking students, and generous alumni all worked toward helping a portion of the local population to become successful in business.

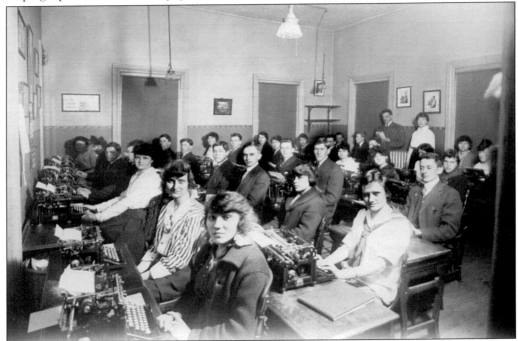

Properly attired and full of hope, these young men and women are poised for the business world. The college attracted many students from the newly arrived immigrant families of South Bethlehem.

A minstrel show performed at Bethlehem Catholic Parochial High School during the late 1930s offered the audience comic skits, variety acts, dancing, and music performed by white students in blackface. Amateur performances like these continued until the 1960s in high schools, fraternities, and local theaters. As blacks began to score legal and social victories against racism and to successfully assert political power, minstrelsy lost popularity. It was unfortunate that most in the South Bethlehem audience were unaware of the significant aspects of black American culture.

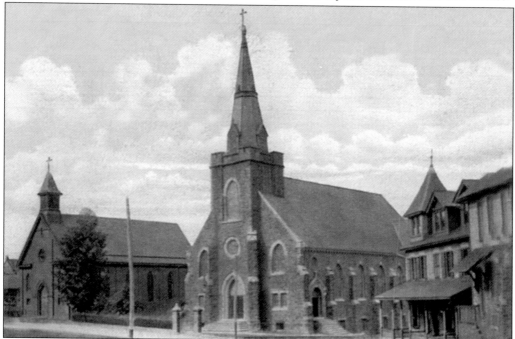

The first SS. Cyril and Methodius Church became the SS. Cyril and Methodius Parochial School when the congregation built a new church in 1906 in South Bethlehem.

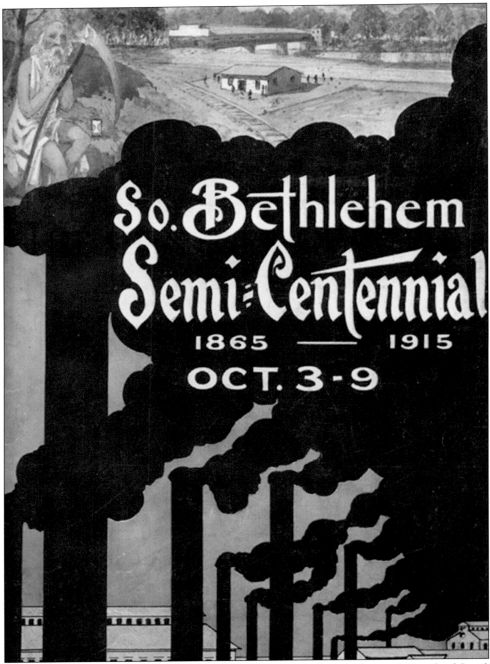

South Bethlehem's semicentennial celebration had gotten underway during the week of October 3–9, 1915. On Tuesday, October 5, Education Day was promptly kicked off at 1:00 p.m. as attending crowds watched daylight fireworks at Fourth and Elm (now Webster) Streets. At 2:00 p.m., an educational parade started at Fourth Street and ended at West Packer Avenue. Once the parade had been dismissed, the ceremony to lay the cornerstone of the new South Bethlehem High School commenced with school board members and others looking on.

Six

THE CENTURY OF STEEL

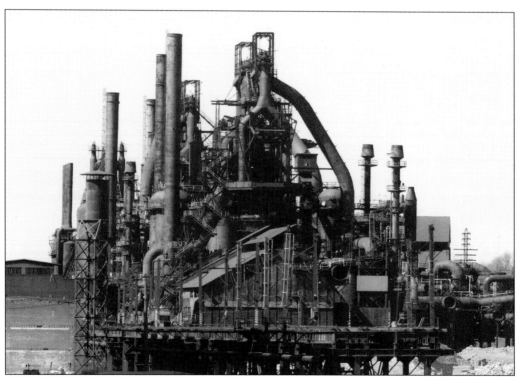

Iconic blast furnaces became the beacon of employment for many and freedom for all during the 20th century, replete with two World Wars, which tested the mettle of the nation and of the Bethlehem Steel plant.

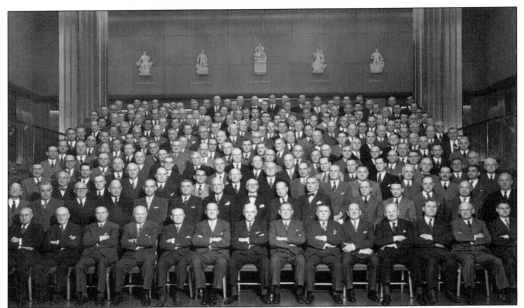

Charles M. Schwab bought Bethlehem Steel in 1903 and served as president and chairman of the board until 1918, when he retired. Eugene Grace (first row, seventh from left) rose from crane operator in 1899 to president of the company in 1913. Under their leadership, the Bethlehem Steel Company became the largest producers of steel in the world. In this photograph, Grace attends a management meeting at Bethlehem General Offices on February 13, 1950.

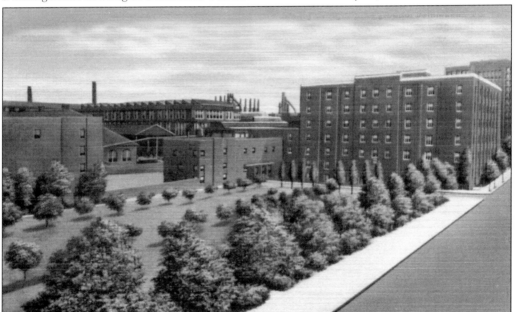

Bethlehem Steel Corporation resembles a college campus in this cleaned-up image of the new modern steel of the 20th century. And yet, in reality, air pollution in the form of dust, soot, ash, and fumes from the Coke Works reminded many that if it were not for these annoyances, there would not be employment.

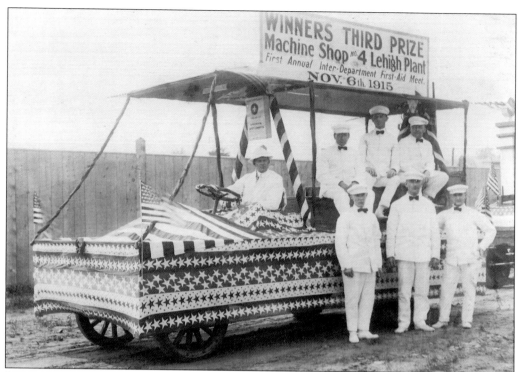

Incentives to inspire camaraderie among steel workers, such as competitions and prizes, led to increased production. In 1916, this float won third prize for members of Machine Shop No. 4.

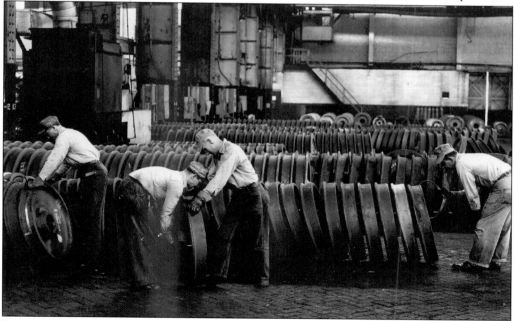

Bethlehem Steel workers do a hotbed inspection of steel-rail car wheels. The wheels were removed from the cooling pits and inspected for surface defects, size, and contour.

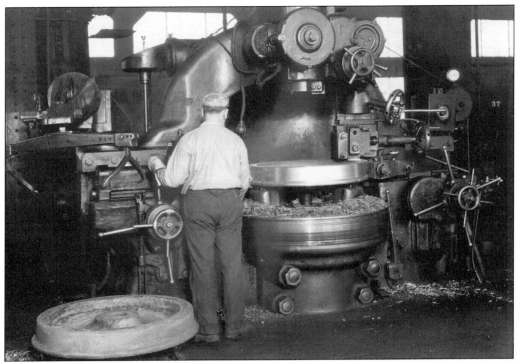

The Tinius Olsen Dynamic Balancer, shown here in Bethlehem Steel's finishing shop, was used to determine the amount of dynamic unbalance in a wheel.

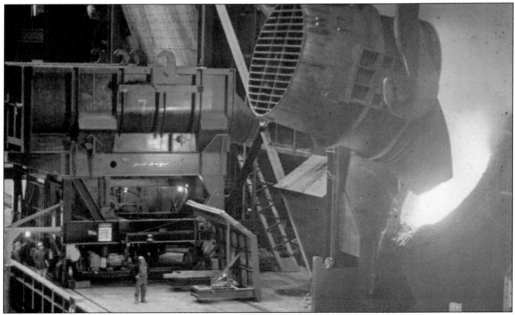

The basic open-hearth furnaces in the Franklin Division produced all the steel used in Bethlehem Wrought Steel Wheels. The steel is cast into large ingots, which are broken down to the proper size for further rolling.

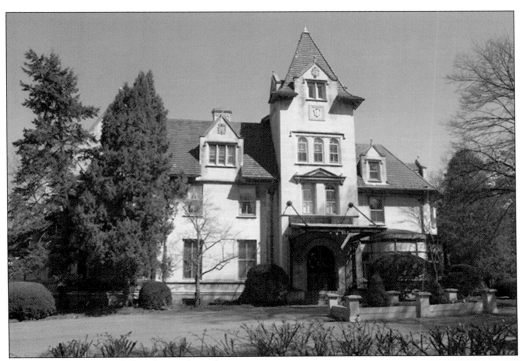

In 1904, Charles M. Schwab purchased the 27-room Linderman mansion. Schwab contracted with A. W. Leh to modernize the home. Schwab knew how to entertain at his home; his social gatherings and poker games were legendary.

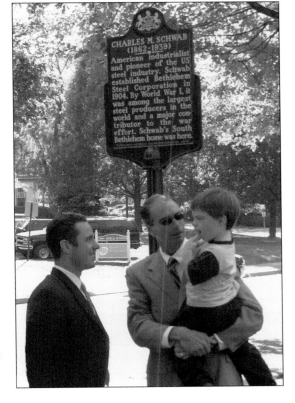

Mayor John Callahan (left), state representative Joe Brennan, and members of the South Bethlehem Historical Society attended the unveiling of the Commonwealth marker to commemorate Charles M. Schwab. The marker was installed at 557 West Third Street in front the industrialist's mansion. Garrett B. Linderman built the mansion in 1870.

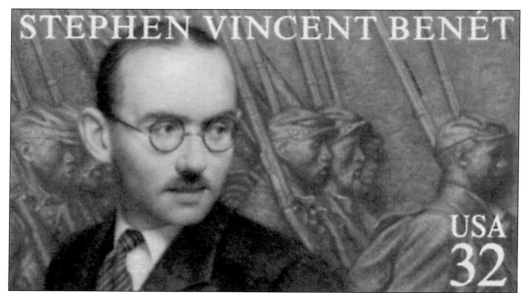

STEPHEN VINCENT BENÉT

USA
32

The U.S. Post Office issued this stamp of Stephen Vincent Benet on July 14, 1998. Benet was born on July 22, 1898, on the second floor of the Albert Ladd Colby house, located at 827 North Bishopthorpe Street, Fountain Hill. Benet received the Pulitzer Price for his poetry twice, in 1929 for *John Brown's Body* and in 1944 for *Western Star*.

The image above is the birthplace of Stephen Vincent Benet. The ochre-colored brick dwelling was built just four years before his birth. His family lived in the house for only a few months before his father was transferred to Buffalo, New York.

South Bethlehem Society board members Dana Grubb (left) and Ken Raniere display the Church Doors of South Bethlehem poster they created. Grubb took the photographs, and Raniere designed the poster.

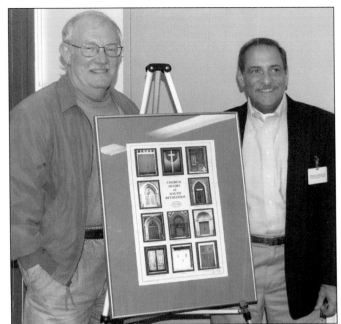

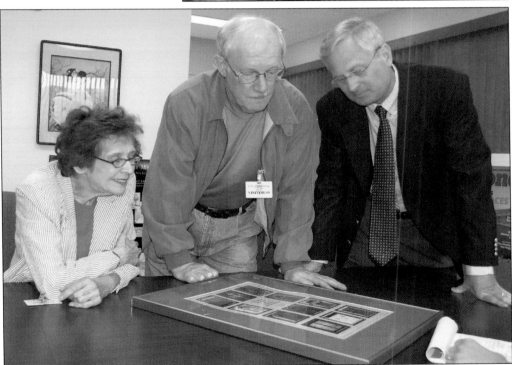

Pictured from left to right, Mary Pongracz, Dana Grubb, and Bob Donchez discuss the closing of the churches Our Lady of Pompeii, St. John Capistrano, St. Joseph, St. Stanislaus, and SS. Cyril and Methodius by the Allentown Diocese. They were all merged to form Incarnation of Our Lord Church in the SS. Cyril and Methodius building.

Marlene "Linny" Fowler, Lehigh Valley philanthropist, converses with Rodger Kingston, who was the keynote speaker for the 22nd annual meeting of the South Bethlehem Historical Society. Kingston is a Walker Evans scholar.

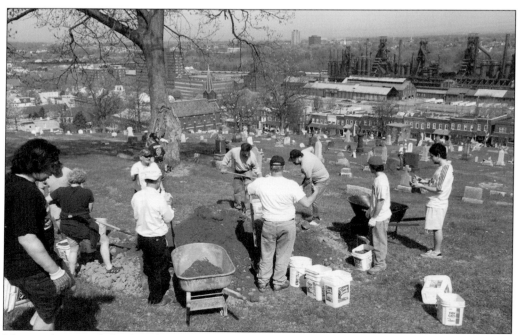

Many volunteers helped with St. Michael's Cemetery cleanup in conjunction with the Great American Cleanup of Pennsylvania on April 25, 2009.

Formerly the E. P. Wilbur Trust Building, today the Flatiron Building's new first-floor tenant is Wachovia Bank, N.A., who was responsible for renovating the banking room to its former splendor. In the late 1990s, the building was purchased by Lawrence Eighmy, head of the Stone House Group, whose mission is to provide "Building Stewardship."

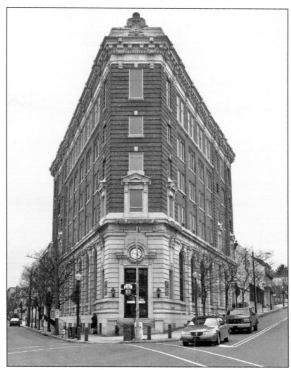

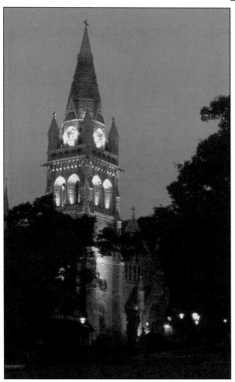

In 2000, the Architectural Lighting Committee of the South Bethlehem Historical Society began exploring the installation of lighting specific structures in South Bethlehem neighborhoods. Lehigh University illuminated the Packer Memorial Church in 2001. Six more buildings have been illuminated in South Bethlehem.

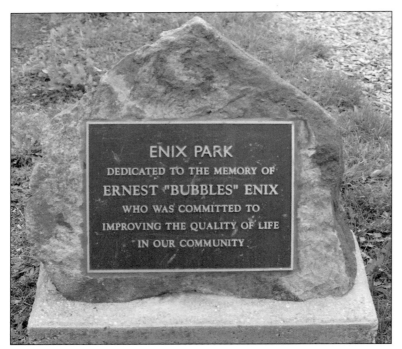

Ernest "Bubbles" Enix Sr. was a church deacon, World War II veteran, and community leader in South Bethlehem. He worked in the Bethlehem Steel blast furnace for 44 years. He earned the name Bubbles as an amateur boxer. In 1997, Enix Park, at Pawnee and Mohican Streets, was dedicated in his honor.

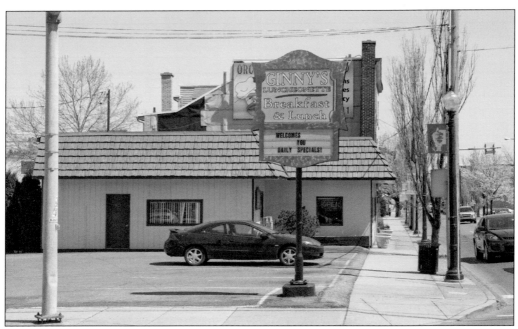

Ginny's Luncheonette was demolished in 2009 by the Pennsylvania Department of Transportation (PennDOT) through eminent domain. In a widening project for Route 412, PennDOT decided that Ginny's would have to be removed. The luncheonette fed South Bethlehem for 20 years.

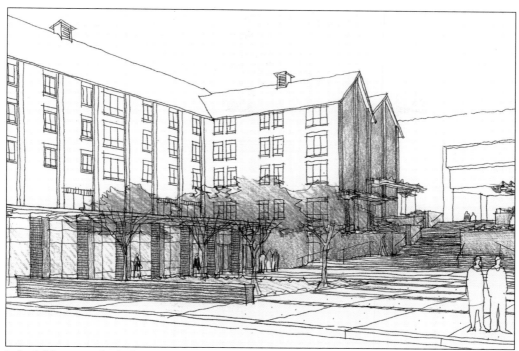

Lehigh University built Campus Square on Morton Street in 2008. The complex included residential housing for students, a bookstore, restaurant, coffee shop, and ice cream parlor.

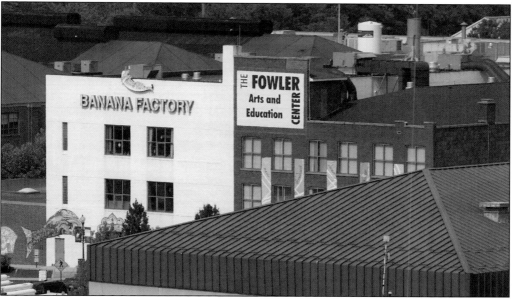

Originally founded in 1984, Bethlehem Musikfest Association relocated its operations to the former Theodoredis and Sons Banana Company warehouse, now officially known as ArtsQuest Banana Factory. Headed by Jeffrey Parks, it includes Musikfest and Christkindlmarkt. In 1998, philanthropist Marlene "Linny" Fowler established the Fowler Arts and Education Center at the Banana Factory at 211 Plymouth Street.

Wilma Balzer (left), longtime South Bethlehem Historical Society member, and the society's founder, Joan Campion, stand in front of St. Stanislaus Church in South Bethlehem.

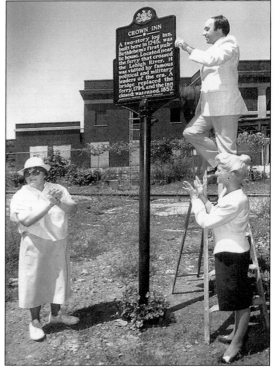

Pictured from left to right, Joan Campion, Jeff Zettlemoyer, and Sandy McKinney pose at the dedication of the first Commonwealth historical marker, the Crown Inn, installed in South Bethlehem by the South Bethlehem Historical Society in 1991.

Bethlehem City councilwoman Magdalena F. Szabo passed away December 13, 2007. She was called "Miss South Side" for her dedication to the concerns of the residents of South Bethlehem. She is shown with Steve Donches.

The former Bethlehem Steel Electric Shop is being redeveloped to become the National Museum of Industrial History. In this photograph dated May 22, 2009, workers are installing new windows.

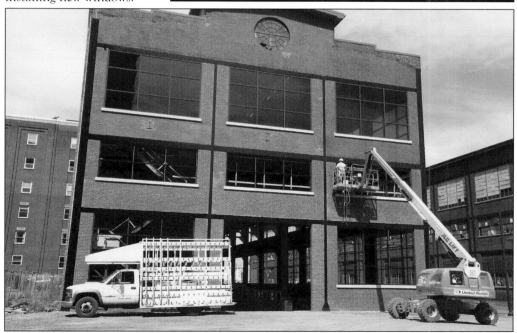

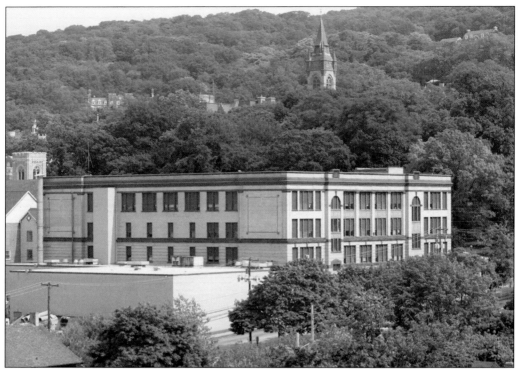

By the time of the celebration of their semicentennial in 1915, the borough of South Bethlehem was large enough to be a third-class city. What better way to show their pride than to invest in the future? The school board commissioned the noted architect A. W. Leh to design a large state-of-the-art high school. The borough was so proud of Leh's architectural drawings that an image of the proposed high school was placed in their semicentennial booklet.

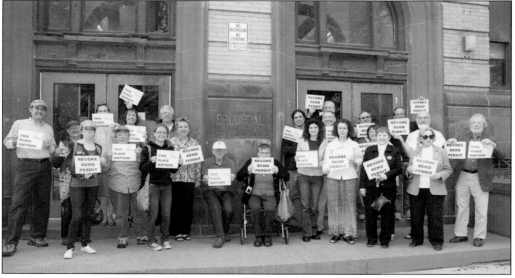

Local citizens and South Bethlehem Historical Society members hold placards, "Revoke Demo Permit" and "This Place Matters," to protest the planned demolition of Broughal School.

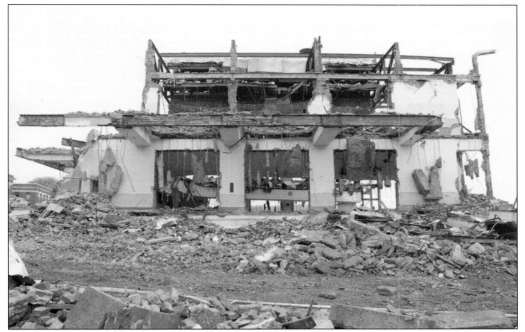

The Broughal Middle School was demolished in October 2009. The elegant building will be greatly missed in the streetscape of South Bethlehem. It was an important part of a group of A. W. Leh buildings that represent the best of South Bethlehem architecture.

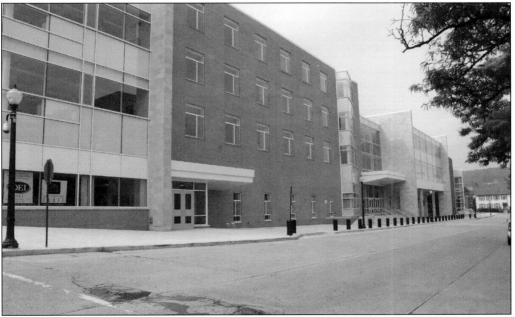

The rebuilt Broughal Middle School opened its doors in September 2009. The new school offers state-of-the art science rooms, a planetarium, a greenhouse, technology labs, a library, and a school store. Touches of the old Broughal School were prominently displayed: two grey marble tablets and two open brownstone books.

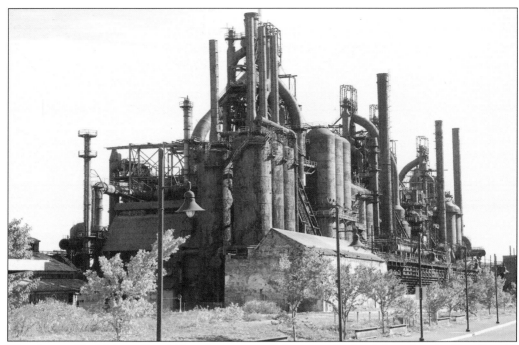

The former Bethlehem Steel blast furnaces will become the backdrop for the SteelStacks entertainment complex to be built by ArtsQuest. On April 26, 2007, demolition began on 10 Steel buildings to clear the way for the Sands Casino. The massive ore bridge was saved to become the entrance to the casino. The five blast furnaces would be left intact.

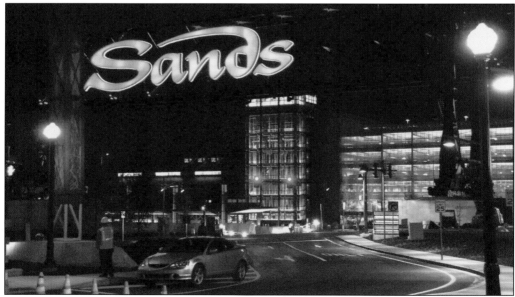

On May 22, 2009, the Sands Casino opened at 9:00 a.m. to a large crowd that had been waiting for hours to enter the 139,000-square-foot casino floor. The casino was designed with an industrial look. The glass, steel, and brick materials are reminiscent of the old Bethlehem Steel in its heyday. Sands will complete its plans for a mall, hotel, and events center when the economy improves.

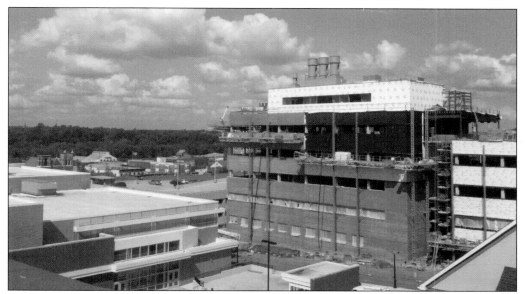

From the vantage point of the old Broughal Middle School roof prior to its demolition in the fall of 2009, the new Broughal Middle School, left foreground, already holds classes to an eager student body. The building under construction to the right is the new arts and science building, "Science, Technology, Environment, Policy, Society" (STEPS), on Vine Street at Lehigh University's Packer Campus.

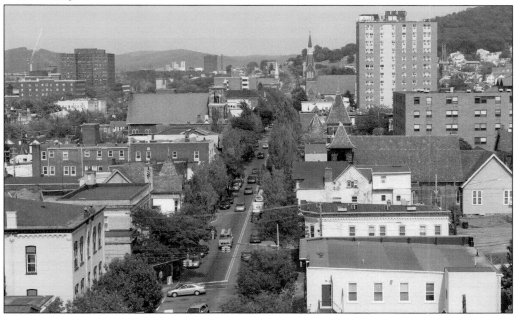

Looking from the rooftop of the Flatiron Building at West Fourth Street and Broadway during the summer of 2008, the Sands Casino, though still under construction at the time, can be seen in the eastern horizon of South Bethlehem. Meanwhile, the former borough still possesses its many church steeples, 19th-century buildings, and evidence of an immigrant population that add to the vibrancy of "the world in a small space."

Discover Thousands of Local History Books Featuring Millions of Vintage Images

Arcadia Publishing, the leading local history publisher in the United States, is committed to making history accessible and meaningful through publishing books that celebrate and preserve the heritage of America's people and places.

Find more books like this at
www.arcadiapublishing.com

Search for your hometown history, your old stomping grounds, and even your favorite sports team.